IMAGES
of America

LAKE WORTH

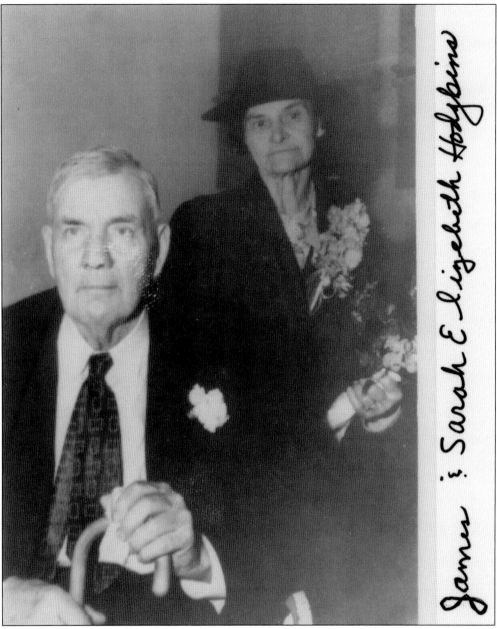

James and Sarah Elizabeth Hodgkins married in Benbrook, Texas, on April 11, 1891. They moved to Niles City on the north side of Fort Worth, where he operated a meat slaughter business before purchasing 240 acres in 1906 on the banks of the Trinity River. James Hodgkins dug a well in the area, which stands today in Lake Worth, Texas, in a memorial park built in his honor. (Courtesy Dale and Eva Lou Hodgkins.)

ON THE COVER: Jerry Starnes, manager at one time of the beach operations at Lake Worth, appears to be enjoying giving these six young ladies a ride in the large Chris Craft boat in the 1950s era. Visitors got a 10-mile ride for $1 a boatload, according to Herb Teasley, whose father owned the rides until they sold the business. (Courtesy Carol Gilbert.)

IMAGES
of America

LAKE WORTH

Lawana Mauldin

ARCADIA
PUBLISHING

Copyright © 2010 by Lawana Mauldin
ISBN 978-0-7385-7862-0

Published by Arcadia Publishing
Charleston, South Carolina

Printed in the United States of America

Library of Congress Control Number: 2009931122

For all general information contact Arcadia Publishing at:
Telephone 843-853-2070
Fax 843-853-0044
E-mail sales@arcadiapublishing.com
For customer service and orders:
Toll-Free 1-888-313-2665

Visit us on the Internet at www.arcadiapublishing.com

This book is dedicated to Ben Mauldin, my dear husband who loves Lake Worth. It also is dedicated to the Lake Worth Area Historical Society.

CONTENTS

ACKNOWLEDGMENTS

There are many people to thank for the information and photographs for this book. First, I must thank the president of the Lake Worth Area Historical Society, Myrt Fowlkes, for offering me the opportunity to do this book. Next, I give a very special thanks to Ken Brower, talented owner of North West Printing and Photography for his hours of diligence in helping me get the images formatted. Also, Dona Stuard's previous research helped greatly. In addition, many thanks go to Dale and Eva Lou Hodgkins, the White family, and David Woodall, relatives of the founding fathers.

Others to whom I owe thanks are Jerrell Elston; Jack Shaddy,; Don Carroll; Jerry Pritchard; Beth and Paul Harmon; Virginia Ross; Lake Worth Public Library; Brett McGuire, City of Lake Worth; Earl Fowlkes; Jami Woodall—Economic Development Lake Worth; Beverly Short Burd; Robby Burd; Billy and Charlotte Wilson; Billy Caldwell; Carol Gilbert; Herb Teasley; Gloria Teasley Thornton; Dub and Kay Ray; Art Arizola; Angie Arizola; Freese and Nicholas Inc. (especially Ken Roberts); Charly Angadicheril, Fort Worth Water Department; Audra Gustafson (coordinator of the Fort Worth Water Business Division); Cindy Robinson, Engineering Department, Engineering Services Division/Flood Plain Administration, City of Fort Worth; Ashanti K. Turner, Engineering Technician II, Transportation and Public Works Department- Vault; and Libby Buck, preservation director Historic Fort Worth, Inc.

Much thanks goes to Betty Shankles, Tom Kullum, and Donna Kruise—the Fort Worth Public Library, Genealogy, History, Archives Division; Jonathan Frembling, Amon Carter Museum Archives; Cathy Spitzenburger, University of Texas at Arlington, Special Collections; Susan Pritchett, Tarrant County Archives; Ivette Ray, Log Cabin Village curator; the Biggers family; the Courtney family; Wayne Williams; John Degroat; Wayne and Lynn Young; Eddie McKay; Jerry Starnes Jr.; Frank Riley; Dr. Janice Cooper, superintendent, Lake Worth School District; Tarrant County Historical Preservation; Carol Godbey; Carla Bezner; Dale Hinz, Fort Worth Police Department; Art Jones, *Times Record* newspaper; Lighthouse Fellowship United Methodist Church; St. Anne's Episcopal Church; Metropolitan Baptist Church; First Baptist Church Lake Worth and Lake Worth First Baptist Church; Northwest Church of Christ; Mayor Walter Bowen and wife, Pat; Frenchy and Janice Tschirhart; Larry Thompson—Northwest Tarrant County Chamber of Commerce; Kevin Henson; Walter Hardin; Tom Reynolds, Reynolds Cattle Company; Suzanne Tuttle, manager of Fort Worth Nature and Refuge; Mike Krocker, Alliance Artists Agency; Curtis and Lee McKay, Clint Narmore, Karen Smith, and Gary Goodman.

Last, but by no means least, thanks to my beloved husband, Ben Mauldin, for all his information and patience. My deepest apologies if I have missed someone in this acknowledgment statement. I give warm thanks to each of you.

INTRODUCTION

In 1909, Fort Worth found a growing need for a large water reservoir after suffering two huge fires that greatly diminished their available water, prompting the building of the largest man-made lake of its time. Engineer John Hawley had suggested as early as 1894 that building a large water reservoir would solve their problem, but the city scoffed at his idea, indicating it would be much too costly. After the last fire, they took another look at the suggestion and decided to proceed with Hawley's plan. Early survey papers of the mid-1800s indicate that James Hodgkins and William Charbonneau, both founding fathers of Lake Worth Village, owned land acquired by Fort Worth as part of the area where the huge water reservoir would be built. The impact of that beginning and the years to follow provide a uniquely woven tapestry embedded in the history of this small community.

After Fort Worth bought the land on which this lake was developed, work began in 1911 and was completed in 1914. Not only was the lake a sparkling pleasure to behold, but so was the winding, meandering road that followed the lush green area around the lake. The council could have named the reservoir after their city; however, after having given it several different names, it was called Lake Worth, the same name the adjacent little community eventually adopted. This small area greatly felt the economic influence of this scenic body of water.

People rushed to the beaches after the lake was constructed, and small businesses popped up, offering a variety of food and fishing necessities as well as a few places to stay overnight. In 1916, Fort Worth built a municipal park. After the first developments on the shorelines of the lake proved profitable, other states took notice. Park facilities of much greater proportions were planned by A. J. Miller and Company of Ohio, along with entrepreneurs E. A. Albaugh and French Wilgus. Miller's specialties included roller coasters. The company came to Texas in 1927, leased the beach and constructed a gigantic theme park that became a huge success, as did the luxurious bathhouse built for bathers to enjoy. Also built was an enormous ballroom where well-known big bands performed. A fine evening of dining and dancing offered pleasure for many years before the whole beach scene was altered by fires and turmoil; yet rebirth gave it new glory, which extended the life of the beach for years to come before it completely disappeared.

The Masonic Lodge also added fame to the era when they built an outstanding mosque overlooking the lake on a point named after George T. Reynolds, who owned land in the area. On Independence Day 1917, the mosque opened. Lavish dinners and entertainment were regular events in this much sought after environment, although its existence was short-lived when an unexplained fire destroyed it a few years later in 1927.

With a few small homes here and there, in 1921, James Hodgkins realized a need for education and donated a small building for the first school, called Rosen Heights, which had just a few students enrolled. The building was moved later to a better location and added on to. Hodgkins had a firm belief in the need for education and paid the first teacher's salary out of his own pocket. Later his friend William Charbonneau gave land to build other schools in the area as well as churches.

During this era, an enchanting castle was built. It was here that celebrity James Stewart would one day stay. The castle's owner, Sam Whiting, supposedly won the land in a poker game. Over a period of years, Whiting and his wife, Elizabeth, built the castle on this site, which overlooks the reservoir, Lake Worth.

In 1923, Amon G. Carter, a wealthy man from Fort Worth, bought over 600 acres from George T. Reynolds and built the famous Shady Oaks Ranch just a few yards from the edge of Lake Worth Village. He entertained persons of renown at this historical resort for many years. After Reynolds died in 1925, his widow, Lucinda, sold acreage for the development of homes that became Indian Oaks, the first neighborhood in Lake Worth. Small businesses such as grocery stores, an ice house, a gas station, beauty parlors, nightclubs, and cafés flourished, although there was limited law enforcement at this time.

Volunteers joined forces with nearby fire stations on call when needed. Then, when the Great Depression came, following on the heels of World War I, enormous hardships developed. One government program, the Civilian Conservation Corps (CCC), provided jobs for many, and land was donated to build a summer camp to accommodate underprivileged children; a Boy Scout Camp was also constructed. Community organizations formed, such as the Parent-Teacher Association, which enhanced the community spirit.

Many years later, as before, the nation faced involvement in what would become World War II. In anticipation of this event, an air base and defense plant developed on the shores of Lake Worth. Once more, a war-related project provided jobs for hundreds of men and women. With the war came homeland restrictions. Food was rationed, as was gasoline. The organization of a garden club in the 1940s enhanced the quality of life, as did several other organizations in the 1950s. The city also became incorporated in the 1950s, and the Lions Club formed. Nearly 20 years later, the Kiwanis Club was established.

A long and dangerous era of gamblers and gangsters made Highway 199, called Jacksboro Highway, which runs through Lake Worth, notorious. The once simple threads of a small community suddenly found themselves bound by the weight of gambling spots and immorality. Because of the undesirable knotted kinks in the environment, civic-minded people became involved in creating a healthier atmosphere; more churches with youth activities developed, as did the number of schools with a broader curriculum and athletic programs. Additional parks, better housing, and stronger law enforcement emerged along with a volunteer fire department. Years later, a full-fledged fire department developed. Shawn Garrett was the first full-time fireman to get paid, in 1991. Mark Cone received pay in 1990 as a part-time fireman.

Many well-documented events have shaped the colorful tapestry of Lake Worth, but without the threads of legends and lore surrounding the Lake Worth Monster, Goat Island Man, German spies during World War II, the discovery of what may well be the grave of a Native American princess, and the belief that one of the oldest homes is built over a Native American burial ground, the profile would not be complete.

A glimpse into the past spotlights a small community, which grew because of a large water reservoir and has developed well beyond its humble beginnings. With the Lake Worth Area Historical Society's determination to preserve the unique history of this community, the author joins in the effort by writing this book, titled *Lake Worth*.

One

EARLY DAYS

After two devastating fires, the need for a better water supply emerged for Fort Worth. With this catastrophic event, the city finally accepted John Hawley's earlier suggestion made in 1894 that a large surface water reservoir would solve the problem. Over 5,000 acres were acquired, and the project started in 1911. Work progressed as men, mules, and machines worked to complete this huge undertaking in 1914 at the cost of $1.6 million.

Soon swimmers and fishing cabins were part of the beach scene. With the obvious interest of the public, in 1916, Fort Worth developed a municipal beach, which was quite popular. Bathers in their woolen swimming suits enjoyed swimming in the sparkling waters, and small businesses soon developed on the beaches. Also cabins were available for rent.

The success of the area caught the attention of A. J. Miller in Ohio. In the 1920s, the company came to Texas and developed a much grander plan for Lake Worth's beaches. They built a 400-foot boardwalk and a very fast, tall roller coaster, as well as adding more rides and various machines to play games and a 300-pound caged gorilla to watch for amusement. Later an enormous ballroom was constructed on the beach called Casino Ballroom, where well-known bands performed. Famous stars such as Dorothy Lamour, Harry James, Tommy Dorsey, and many others drew tremendous crowds as they headlined the program.

For some, a scenic ride around the meandering road was the ultimate pleasure. For others, the lure of the cool lake water was enough. For thousands more, magical moments were created to remember forever an evening of dining and dancing in the fabulous ballroom, where the wind passed through the huge open doors with a glimmering, shiny silver ball twirling overhead. Throughout a long and eventful life, many changes took place on this historic beach with its theme park and the overshadowing, exquisite bathhouse as well as the enchanting ballroom. Although the theme park and ballroom no longer exist, the drama surrounding this era lives on forever in the archives of history.

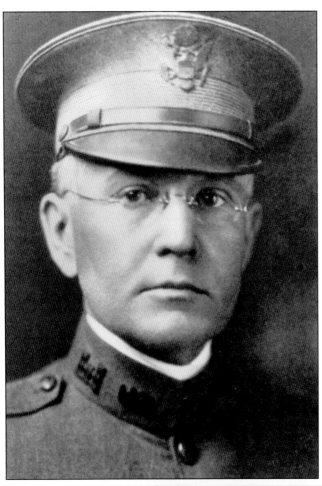

These images are of John Hawley, an engineer who suggested as early as 1894 when he was but a young man that a large surface water reservoir would provide the necessary water needed by Fort Worth. Years later in 1911, the city accepted his suggestion and hired him and two other engineers to oversee the project. The project was completed in 1914, and Hawley resigned. He is the founder of Freese and Nicholos, a well-known engineering firm. (Both courtesy Freese and Nicholos, Inc.)

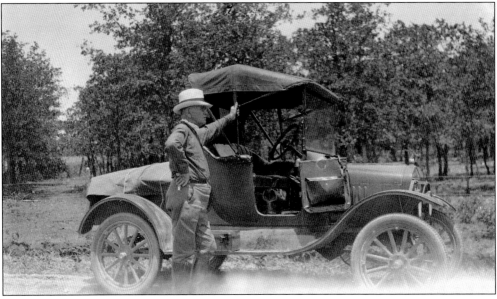

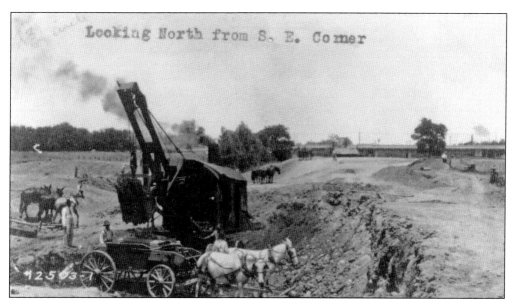

Looking North from S. E. Corner

This is the early construction of the Lake Worth Spillway in 1912, with man, mules, and machines working together. After several years, and at the cost of $1.6 million, the whole project was completed in 1914. To the surprise of all, a massive rain filled the reservoir in three weeks instead of the expected three years. The general public quickly seized the golden opportunity to enjoy swimming in the sparkling water of the large new lake. It was not long before a few small cabins and docks appeared, with small business ventures soon to follow. (Both courtesy Freese and Nicholos, Inc.)

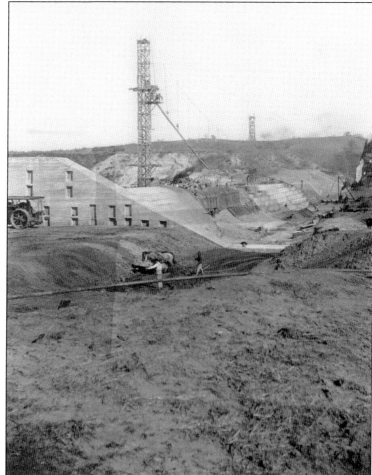

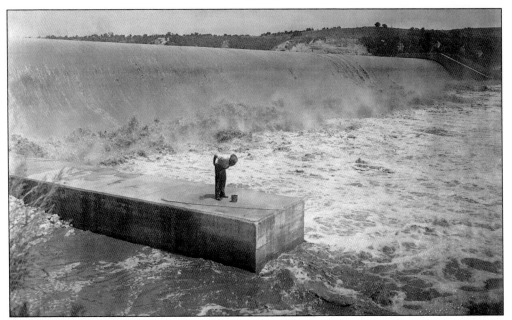

Great amounts of heavy rainwater tumble over the spillway in this image. In order to maintain a constant level, water may be run off at times. This man does not seem to mind the turbulent waters below. Perhaps he sees lots of fish or is just wondering if he should not even be there. (Courtesy *Fort Worth Star Telegram* Collection, Special Collections, University of Texas at Arlington Library, Arlington, Texas.)

After the first bathhouse made of wood burned in 1928, it was replaced with a new stucco building of Mediterranean-style motif, as were most of the other structures. By 1930, the park was open again in spite of the Depression. Those with money came and spent, allowing the park to experience great success. (Courtesy John Degroat.)

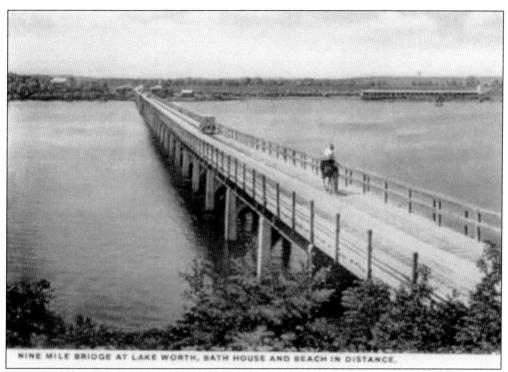

NINE MILE BRIDGE AT LAKE WORTH, BATH HOUSE AND BEACH IN DISTANCE.

The first bridge over Lake Worth was called the Nine Mile Bridge because it was exactly 9 miles to downtown Fort Worth. Although cement supported the bridge, the top portion was made of wooden planks, which did not hold up well. When the bridge was later moved to another location, wooden planks were not used. (Courtesy John Degroat.)

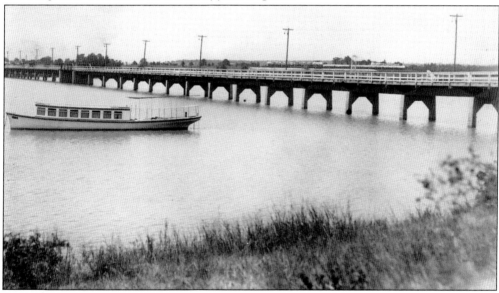

This is another view of the Nine Mile Bridge after it was moved to a better location. The large boat helps give more perspective to its size. Thousands traveled over this bridge to the fabulous Casino Beach and Ballroom. Note the different type of support for the structure. (Courtesy John Degroat.)

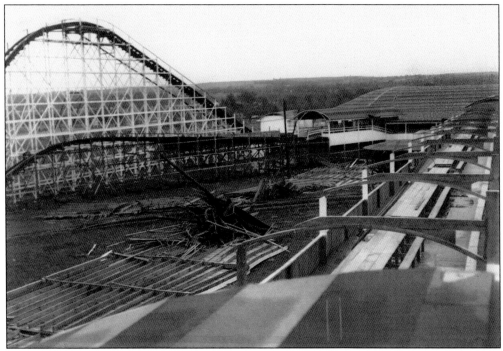

Construction for the theme park began in 1927. The tall roller coaster shown here was built under the direction of one of the park owners, who was an expert in this field. Three trains carrying 24 passengers each would climb the lift hill, 72 feet upward. As gravity gained control, the cars ascended, then descended, building speed for the next climb. The roller coaster traveled at a speed of 60 miles an hour. The below image is an aerial view of Casino Beach with the bathhouse in the forefront middle and the large ballroom to the far right. (Both courtesy John Degroat.)

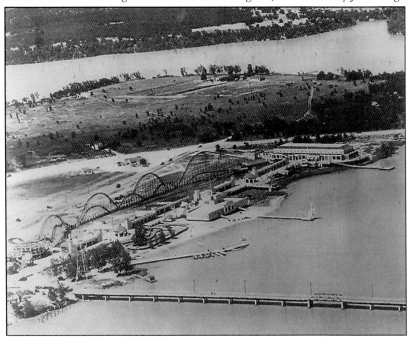

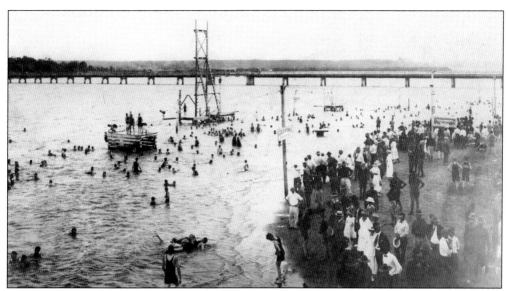

After the completion of Lake Worth, it quickly became the popular place to gather for picnics and to swim. Notice the dark swimsuits the ladies have on, most likely made of wool, the custom of the 1920s era. Those on shore have on interesting attire also. (Courtesy John Degroat.)

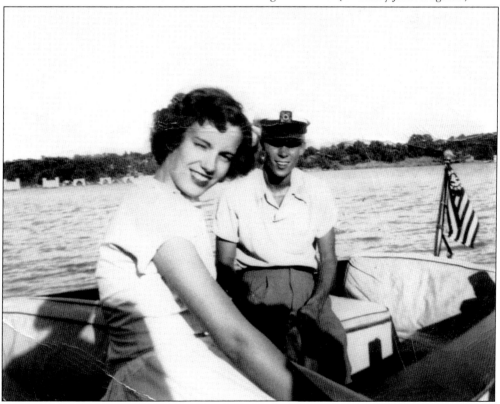

This photograph was taken around 1949 or 1950. The handsome young man wearing the captain's hat is Herb Teasley, who is giving his girlfriend, Marcy King, a ride in his boat on this obviously sunshine-filled day as they squint and smile at the camera. (Courtesy Herb Teasley.)

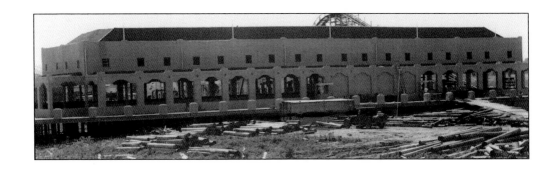

The elegant 31,000-square-foot Casino Ballroom was the heart of the whole beach scene at Lake Worth for many years. Its longevity was phenomenal considering the various mishaps during its existence. The large seating capacity of 2,200 allowed for many diners to enjoy reasonably priced meals for $2. The smooth hardwood floors provided an excellent area for dancers as they twirled under the swirling silver ball that hung overhead. The openness of the ballroom allowed cool breezes to pass through as big band performers filled the room with their famous melodies, creating unforgettable memories for those in attendance. (Both courtesy Art Jones.)

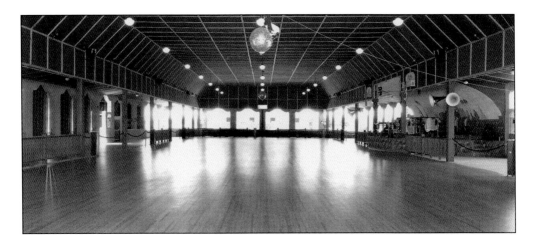

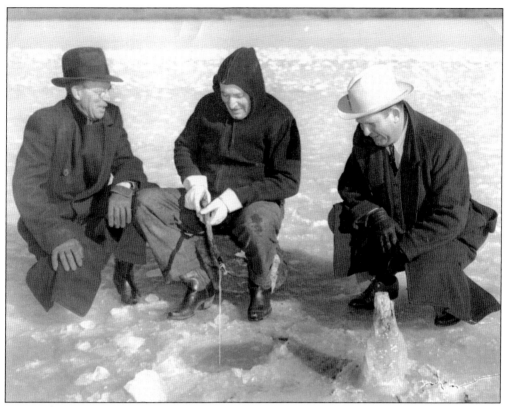

Fishing through a hole in frozen Lake Worth is a novelty in Texas. In 1930, these three men took advantage of the situation and look determined to make a catch. From left to right are three friends: lake patrolman Dutch Carroll, Jack Shytles, and a man believed to be William Beason. (Courtesy Don Carroll.)

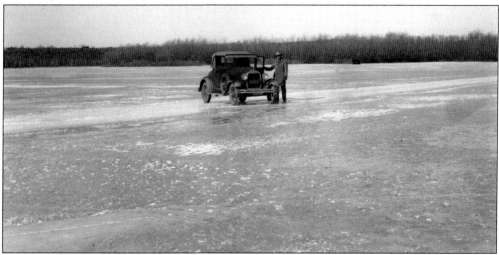

Lake Worth froze over more than once during the 1930s and 1940s. According to archives and news reports, some places had a thickness of 7 inches during the freeze of January 1930. Not only had Dutch Carroll fished in an ice hole, but he drove onto the frozen lake, which obviously was strong enough to support him and his patrol car. (Courtesy Don Carroll.)

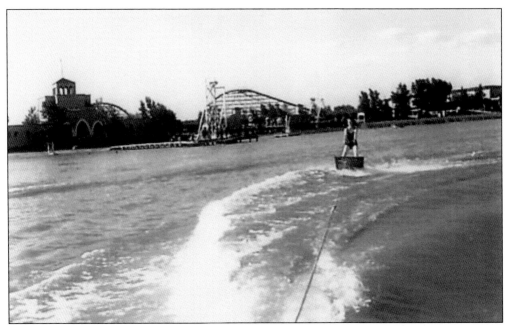

Water sports provided fun for many in the waters of Lake Worth. This young lady in her one-piece swimsuit appears to have the necessary skills to ski successfully. Note the beautiful bathhouse to the left behind the tree line. Look to the right to see the towering roller coaster. (Courtesy John Degroat.)

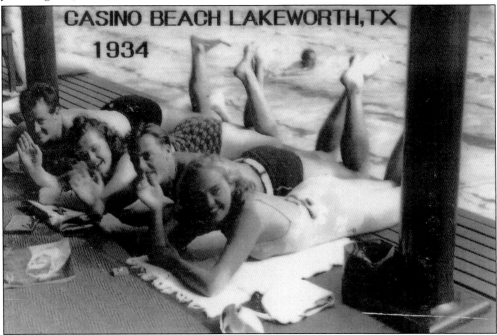

This group of swimsuit-clad unidentified young ladies and gentlemen seems to have no worries even though the Depression was on in 1934. With smiling faces and upturned heads, they appear to be greeting the photographer. In the background is another swimmer playing in the lapping waves. (Courtesy of Northwest Tarrant County Chamber of Commerce.)

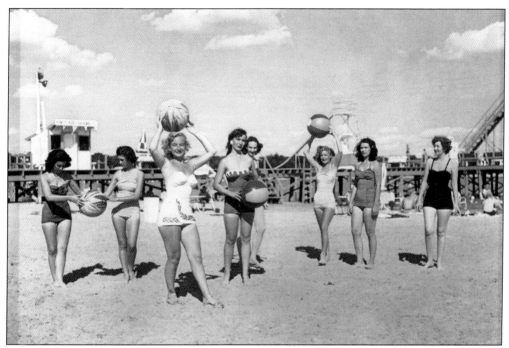

These pretty unidentified young ladies in their beautifully designed swimsuits, with bare feet digging into the sand, make one wonder if they were doing exercises or just having fun on Casino Beach with the large beach balls on a warm summer's day. Could it be they were just posing? At any rate, pleasure radiates out of the photograph, taken in the late 1940s or early 1950s. (Courtesy Carol Gilbert.)

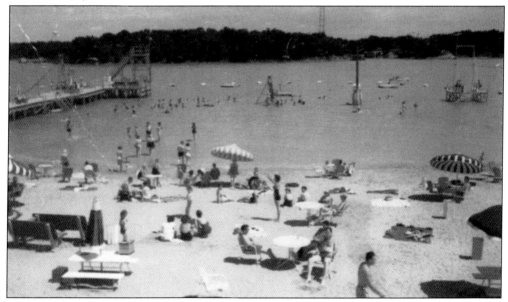

This beach scene is believed to be in the late 1940s or early 1950s. At the top on the left is the lifeguard's station. In the water are quite a few swimmers with many others on the beach under the umbrellas or just basking under the sun, if not taking a stroll. One can imagine what a bright sight the striped umbrellas presented. (Courtesy Carol Gilbert.)

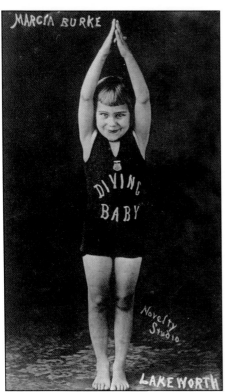

Poised, this smiling young beauty looks ready to prove she deserves the title "diving baby" written on her swimsuit. Although a name is at the top of the image, it is unknown if it belongs to the child featured here with her arms held high over her head. Note the name of the lake at the bottom. (Courtesy John Degroat.)

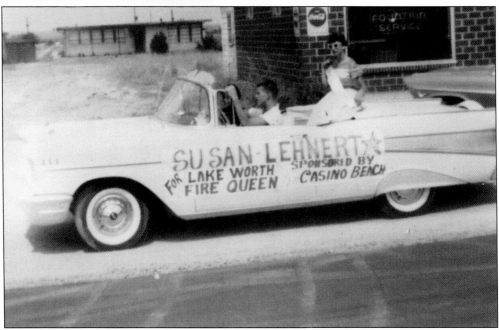

Riding on the top of the back seat of this convertible is a pretty contestant identified on the side of the car as Susan Lehnert, running for Lake Worth's Fire Queen. Her sponsor is Casino Beach. The driver is unidentified. Lehnert's present-day status is unknown. (Courtesy Lake Worth Public Library.)

20

Two

COMMUNITY DEVELOPMENTS

When land was acquired for the lake construction, two of the men holding acreage acquired by Fort Worth were James Hodgkins and William Charbonneau. Early plat records indicate their ownership dates back to the late 1800s and early 1900s. Both men cared greatly for the education of children and donated their time, land, and money to meet this educational need. Hodgkins donated a small building and land for the first school in 1921 and is considered the founding father of Lake Worth. A recent discovery of a photograph of his good friend, Charbonneau, now gives a visual image of him as well.

Charbonneau also donated land later on for schools and churches. In addition, each man had his own business endeavors. Hodgkins owned a trading post while Charbonneau raised Percheron horses. In 1923, another landowner and cattle baron named George Reynolds sold land in the area to Amon Carter. After Reynolds's death in 1925, his wife, Lucinda, later sold acreage that became the first community to develop in Lake Worth, called Indian Oaks. Additionally, a generous man heavily involved in the community development was J. R. Foster, who owned a store that sold bait, ice, and grocery items, and he later added gas pumps to his business.

From the 1920s through the 1950s, when the city of Lake Worth was incorporated, and beyond those years, other persons and events impacted the early development of the city. Small cafés and fast-food drive-in restaurants became popular, as did a local theater and skating rink. Larger restaurants such as Chenualt's (Courtney's) were established and offered an interesting variety of food and decor. At the same time, a number of small grocery stores opened, as did beauty shops and barbershops. Photographs depicting these developments are not all included in this chapter, but a good representation records many of the places and people that affected the development of Lake Worth, Texas.

George T. Reynolds, a cattle baron, drove cattle over the Chisholm Trail and other cattle trails. He is one of the original owners of Reynolds Cattle Company. Listed in the 1900 Census of Tarrant County, Reynolds married Lucinda Elizabeth Matthews in his youth. After his death in 1925, Lucinda Reynolds sold land to a developer who built houses in Indian Oaks, Lake Worth's first community. (Courtesy Tom Reynolds.)

Lucinda Elizabeth Matthews married George T. Reynolds when she was 16. The couple lived in several locations across Texas. After his death, she was instrumental in giving Native American names to the streets in the development of the first community in Lake Worth. (Courtesy Genealogy, History, and Archives Unit, Fort Worth Public Library.)

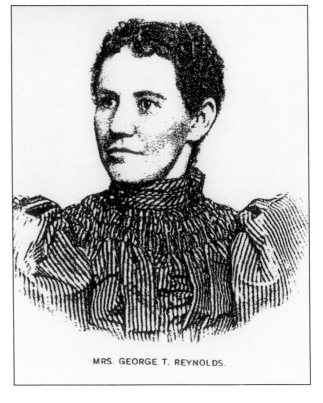

MRS. GEORGE T. REYNOLDS.

James Hodgkins is shown here with his beloved dog, Carlotta. Note the rounded iron headboard to the right. Also typical of the era is the cane-back wheelchair with a cane leg rest as well. Hodgkins suffered from the effects of diabetes. (Courtesy Dale and Eva Lou Hodgkins.)

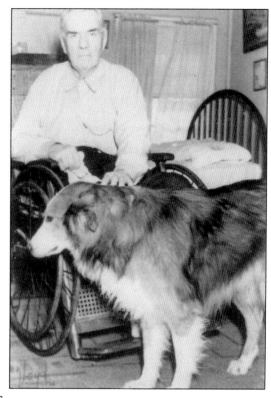

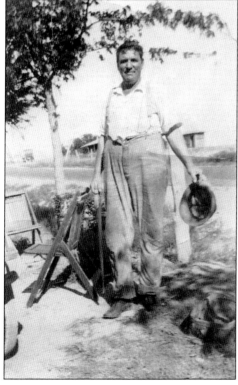

A handsome young man, Hodgkins is shown outside on a warm day with his hat removed as he stands near the shade of a tree and the dappled sunlight falls across his work area. Vintage wooden folding chairs are nearby. His narrow shoes appear to be of good-quality leather. (Courtesy Dale and Eva Lou Hodgkins.)

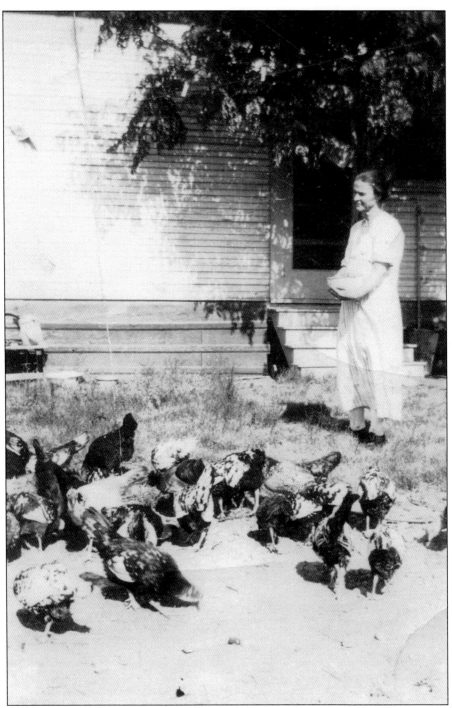

Elizabeth Hodgkins had a large flock of chickens, which kept them in fresh eggs. Here she is shown feeding them as they peck at the grain she has thrown on the ground. The day must have been warm with her short sleeves, but as was the style, her dress was long. Mrs. Hodgkins enjoyed having family dinners, which meant lots of cooking. Eggs and chickens were likely used in many of her fine meals. (Courtesy Dale and Eva Lou Hodgkins.)

These four unidentified youngsters pose in front of Everett Hodgkins's neon sign company. Everett Hodgkins is the son of James Hodgkins. In the background is a sign advertising minnows, not unexpected for the lake area. One can imagine what that sign would look like if it glowed in the dark—maybe it did, for night fishermen need bait just as much as daytime fishermen. (Courtesy Dale and Eva Lou Hodgkins.)

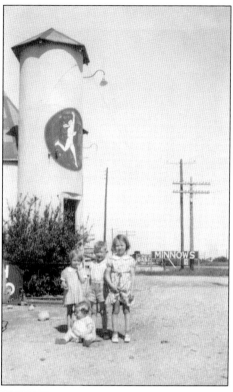

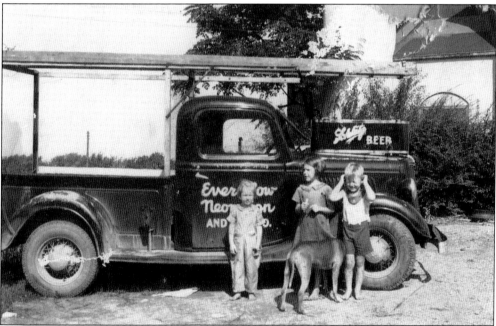

Everett Hodgkins had a truck that advertised his Everglow Neon sign business. As seen in this photograph, the truck was equipped with the necessary framework to carry large signs to his customers. In the picture, from left to right, Sarah, Barbara, and Dale Hodgkins pose with their dog, hiding his head. (Courtesy Dale and Eva Lou Hodgkins.)

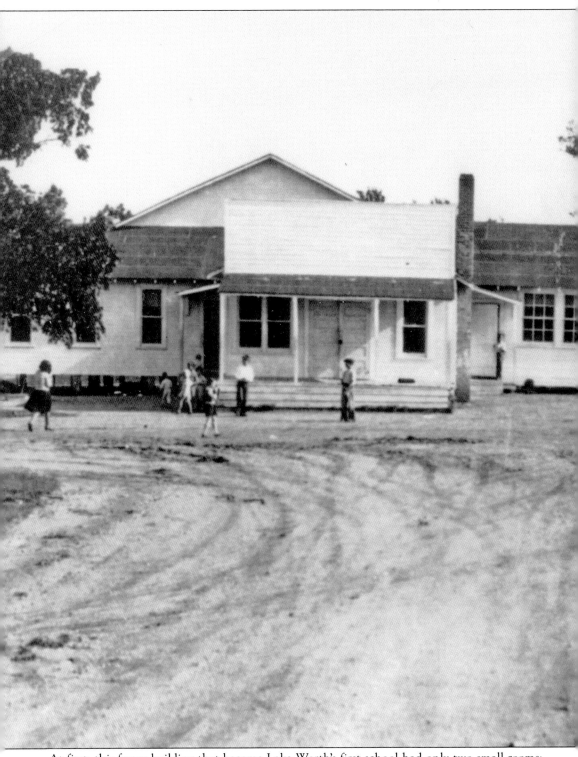

At first, this frame building that became Lake Worth's first school had only two small rooms; some believe it had only one large room. The building was donated in 1921 by James Hodgkins,

who had great interest in the education of children. It is unclear if the land was donated by his friend William Charbonneau or if he donated it himself. (Courtesy Ben Mauldin.)

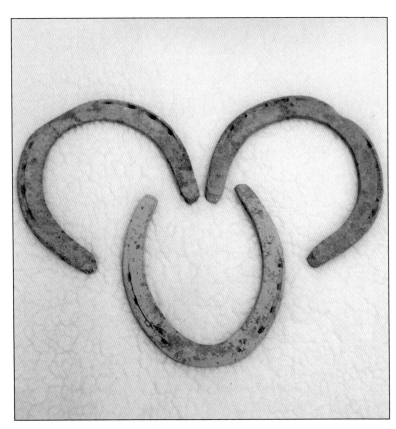

These three large horseshoes were found under the old Methodist church building in Lake Worth when it was being renovated in the 1970s to become a community center. It is believed that William Charbonneau placed them there since he donated land for that building. Originally there were four horseshoes, but the owner of the building opted to give one to a friend. (Courtesy Ben Maudlin.)

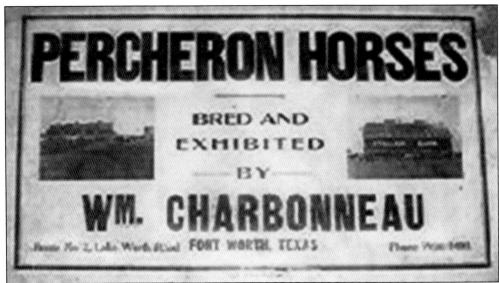

This sign advertised William Charbonneau's Percheron horses. The breed is larger than most horses. He would often let Carl Short's daughter Beverly ride one of his smaller horses when her horse was ill or had been sold. Charbonneau married a schoolteacher, Loree Turner Rogers, who taught in Lake Worth. They had one daughter named Lynette. Charbonneau was a vast land owner and a generous man. (Courtesy Dona Stuard.)

28

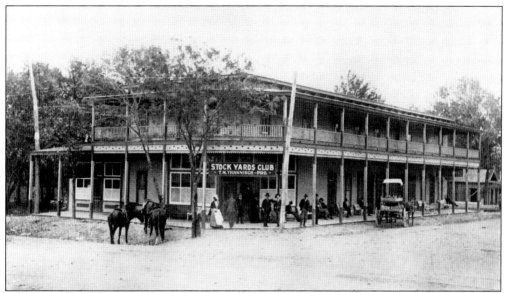

T. M. Thannisch bought land in north Fort Worth about 1894. His name is shown here scrawled across the front of the Stockyards Club. He had part ownership of the first icehouse in north Fort Worth and had a partnership in the first hunting and fishing lodge in Lake Worth, called the Vine Lake Lodge. He rented boats and other concessions. (Courtesy Genealogy, History, and Archives Unit, Fort Worth Public Library.)

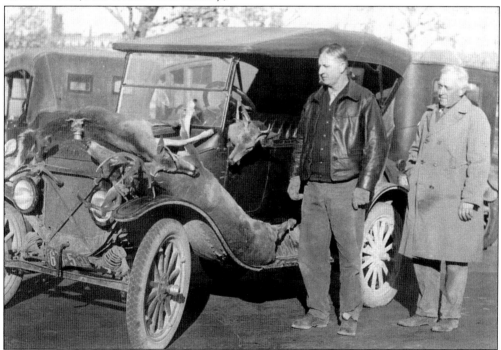

J. R. Foster, an ambitious, hardworking man, enjoyed taking one nice hunting trip each year to the Davis Mountains in Texas. Here he is shown standing near the rear of the vehicle wearing his overcoat with an unidentified hunting friend. Their yield is draped over the hood of the vintage touring car as well as inside. (Courtesy David Woodall.)

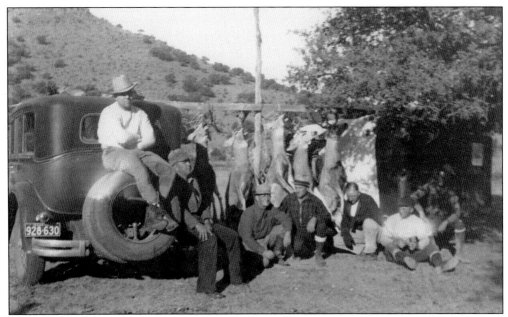

J. R. Foster, third from the right, is squatting down with his gloved hand hanging near the ground. The other six men are unidentified. In the background is a view of the Davis Mountains, where Foster enjoyed hunting. It is unknown but a good possibility that he hunted on the over 1,000-acre ranch owned by the Reynolds family, who also had land in the Lake Worth area in the 1920s. (Courtesy David Woodall.)

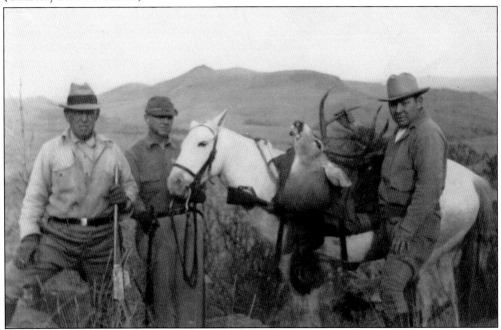

In this photograph, Foster is the man holding the rifle. It is assumed the dead deer is his kill. The white pack horse does not look too happy to be carrying such a heavy load, but the three men, the other two unidentified, appear quite happy with the arrangement; perhaps it had been a good hunting day for them all. (Courtesy David Woodall.)

This is the Foster family. It is assumed the poker faces are because it was not proper to smile when having a photograph taken during the earlier Victorian period. From left to right are (first row) Theodore, whose nickname was "Doschy"; (second row) Ellan, Kate, Sarah, Codie, and Maggie; (third row) Luther, J. R., Ira, and Lonnie. (Courtesy David Woodall.)

As the Foster family grew older, a more relaxed expression was just fine, as seen in this photograph. The names are uncertain, but some resemble those identified in the previous photograph. There is less gingerbread trim on the background house as compared to the earlier photograph. (Courtesy David Woodall.)

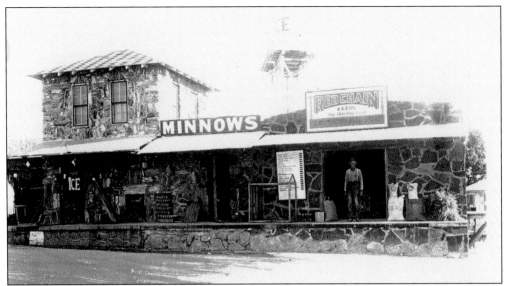

J. R. Foster moved to Fort Worth, Texas, in 1902. After he and his partners opened the North Fort Worth Ice Plant, Foster discovered what a good business this was because few people had mechanical refrigerators. When the Lake Worth reservoir was constructed, he opened his own ice plant and grocery store near the first bridge over the lake. He wisely moved it to a better location nearer the relocated bridge on Jacksboro Highway, shown here, and added the gas pumps out front. The vintage pumps shown here are those that many antique lovers enjoy owning. (Both courtesy David Woodall.)

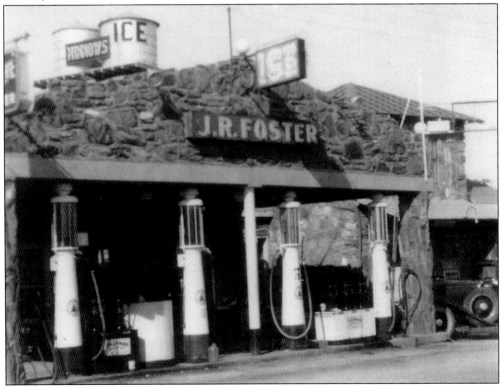

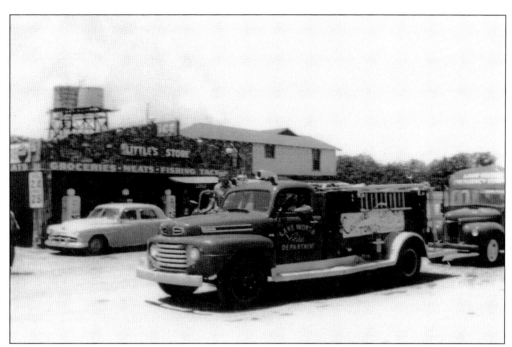

Foster operated his store for a long while before he sold it. At one time, the store belonged to Basil Martin and Buster Little in a joint ownership. Only the name "Little" is on the building in this photograph. It appears this owner carried about the same types of items as Foster. Notice the vintage fire truck parked in front and the faded gasoline sign advertising gas for 24¢ and 25¢. (Courtesy Beth and Paul Harmon.)

This is Carl Short with an ice block on his back from J. R. Foster's ice plant in north Fort Worth. Short often delivered ice to the Lake Worth area, where he lived and also held the office of constable in the 1940s. After Foster moved his ice plant to Lake Worth, Short continued to work for him. (Courtesy Beverly Short Burd.)

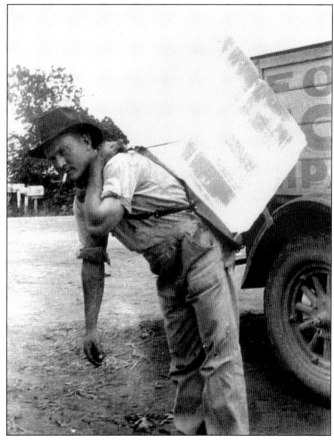

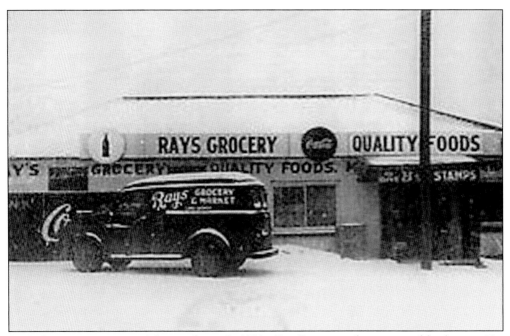

Ray's Grocery store opened during the early 1930s. Roy Ray carried a variety of food items. His delivery truck's side panel offered the perfect spot for advertising. Notice the stamps sign to the right of the picture. Dub Ray, the owner's son, remembers working in his father's grocery store. The son is still living at the age of 91. (Courtesy Dub and Kay Ray.)

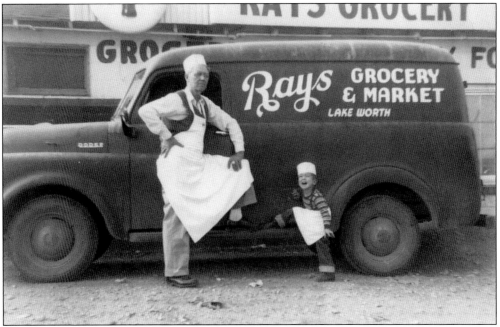

In this photograph, the senior Mr. Ray poses for his picture to be taken with his small grandson, Roger. The small boy appears delighted to have on a hat and apron like his grandfather. His short little leg is stretched to rest his feet on the running board, also just like Mr. Ray. (Courtesy Dub and Kay Ray.)

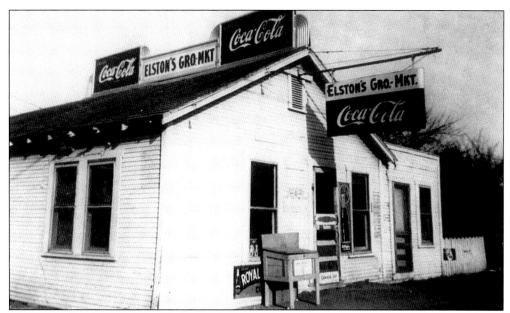

The Elston family owned this grocery in Lake Worth during the late 1930s or early 1940s. A bread box placed near the window is where an early morning deliveryman left bread before the store opened. Later during the day, another delivery was made inside the store to fulfill the afternoon bread needs. (Courtesy Jerrell Elston.)

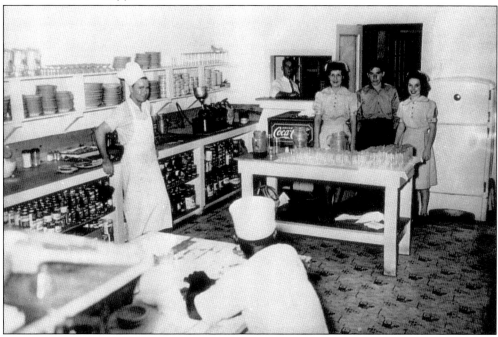

This photograph was taken inside the kitchen of Naiomi Elston's café, located across the street from Casino Beach. Many customers enjoyed the delicious meals served at reasonable prices. Standing near the door, from left to right, are Ernestine Woodruff, Jerrell Elston, and Marzell Elston Raymond. Carl Elston is standing at the pass-through window. The chefs are Ray Jones (standing) and Burl Lewis (seated). (Courtesy Jerrell Elston.)

ELSTON'S PLACE
At LAKE WORTH

FRESH CATFISH, Combination Salad and French Fries

$1.00

1 Breaded Veal Cutlets

Shoestring Potatoes, Gravy and Salad.

65c.

2 Special Steak Dinner

Large T-Bone served with Potatoes, Wop Salad and Buttered Rolls

$1.00

3 Baby Beef T-Bone

Served with French Fries and Combination Salad.

75c.

4 Virginia Ham

With Natural Gravy, Apple Sauce and Fried Potatoes.

75c.

5 Elston's Special Cold Plate Assorted Meat

With Cheese and Potato Salad

65c.

6 Chicken Dinner

One Half Spring Chicken, French Fries, Cold Slaw, Cream Gravy and Buttered Rolls.

$1.00

7 Country Style Chicken

3 pieces Chicken, French Fried Potatoes, Lettuce and Tomato Salad, Gravy.

75c.

8 Barbecue Dinner

Choice of Barbecued Ribs or Beef, Shredded Lettuce with Tomatoes, Shoestring Potatoes, Pickles and Onions and Buttered Rolls.

$1.00

9 Choice Pork Chops

Served with Potatoes, Salad and Brown Gravy **75c.**

10 Chicken Fried Steak

With Potatoes and Peas

65c.

As one looks over the menu from the Elston's Place of the 1940s, it is interesting to find such a variety of meats. Nothing on the menu is more than $1. With such good prices and good food, it is easy to see why a steady flow of customers frequented the popular eating establishment. (Courtesy Jerrell Elston.)

Lake Worth Drug offered a variety of over-the-counter medicine such as aspirin, but no prescription drugs were sold. In addition, Curtis Pritchard, the owner, sold grooming products as well as an assortment of other items. Some of the most popular purchases included ice cream, soft drinks, and film for cameras. Pritchard also served on the school board. (Courtesy Jerry Pritchard.)

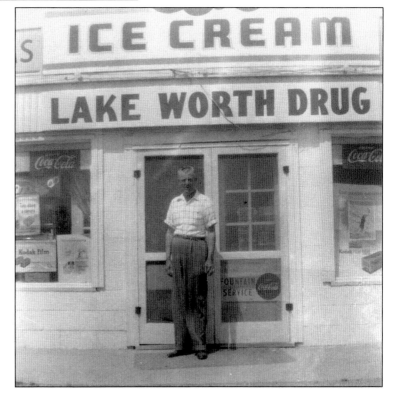

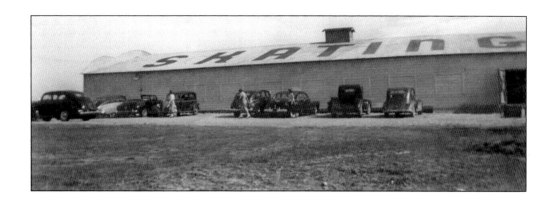

The Elstons enjoyed owning another business, a skating rink, which allowed youngsters as well as adults to engage in a healthy form of exercise. The care and concern they felt for their customers built a fine reputation in the community. They were at this location in 1949. An interesting number of vintage cars are parked along the outside rink wall. Another view is shown below in 1950 with more vintage cars shown. At this time, Jerrell Elston, a teenager with great skating ability, was employed by his family as the floor manager. (Both courtesy Jerrell Elston.)

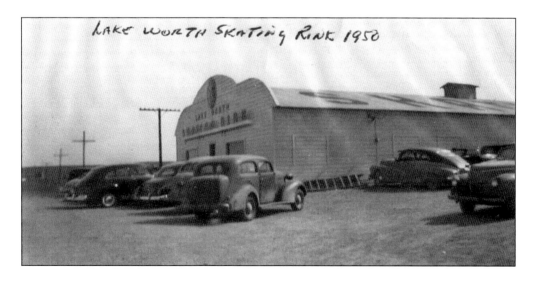

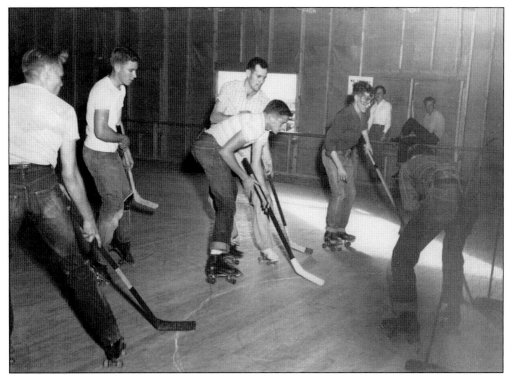

The roller hockey team, inside the Lake Worth Skating Rink in the late 1940s or early 1950s, exhibits much concentration in the battle to control the hockey puck. Spectators are unidentified, as is the goalie. The other players are, from left to right, Glenn Easley, Billy Caldwell, Roy Gene Turpin, Tom Pat Presley (bending over), and Jerrell Elston, wearing glasses and holding out his small finger from an injury. (Courtesy Jerrell Elston.)

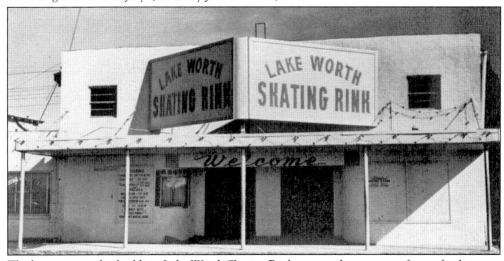

The large sign on this building, Lake Worth Skating Rink, was easily seen, even from a far distance. As customers approached the entrance to the rink, a heartwarming sign reading, "Welcome," greeted them. Once inside, skaters would put on their shoe skates and enjoy an entertaining, healthy activity. Many took pride in their skating abilities and could be seen skating backwards as well as forward in interesting, difficult patterns. (Courtesy Jerrell Elston.)

The owner of this business, Preston Stum, stands in front of his barbershop located in Lake Worth, Texas. The year was 1938, and the young boy is Jerrell Elston, who looks proud of his new haircut. His striped overalls were popular attire at that time. (Courtesy Jerrell Elston.)

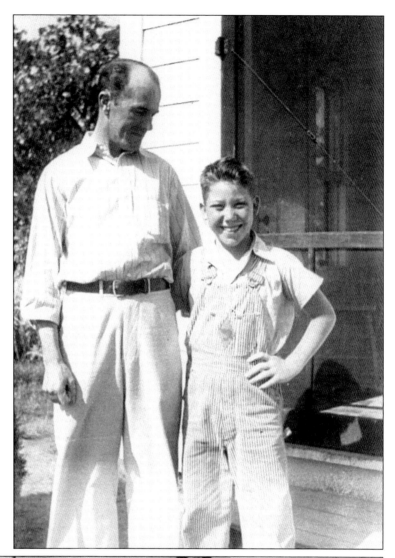

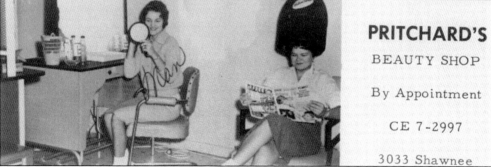

PRITCHARD'S

BEAUTY SHOP

By Appointment

CE 7-2997

3033 Shawnee

Most small towns have one or more small beauty shops, as shown here. Delores Pritchard had her shop in her home during the 1950s, often the situation. The two young ladies are unidentified but appear to be happily occupied with their time of beauty. (Courtesy Lake Worth High School and Clint Narmore.)

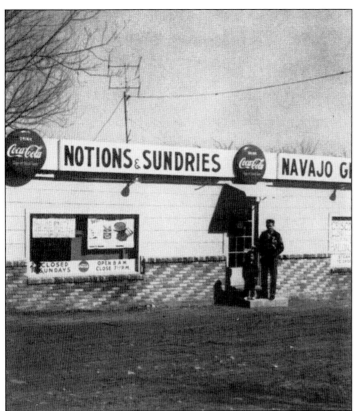

Since the streets of the Indian Oaks area of Lake Worth are named after Native Americans, it was an easy identification for the Navajo Grocery in the 1960s. Standing on the front door stoop are two unidentified persons, one a young child, the other a teenager in his letter jacket. (Courtesy Lake Worth High School and Clint Narmore.)

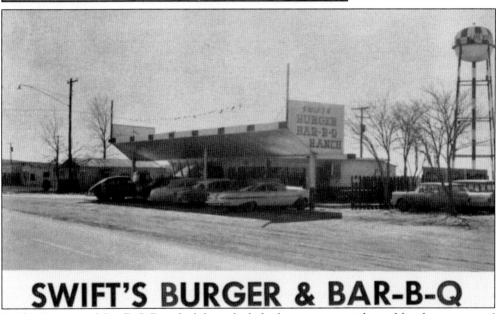

SWIFT'S BURGER & BAR-B-Q

Swift's Burger and Bar-B-Q Ranch did not lack for business, as evidenced by the customers' cars out front and on the side. The community is known to have enjoyed eating at this popular restaurant, not only for the delicious barbeque served but also the outstanding burgers. (Courtesy Lake Worth High School and Clint Narmore.)

Jacob Cleaners offered a variety of things to the public, including alterations, laundry care, and dry cleaning. Perhaps the most important services could be assured by the large sign atop their building offering "first in quality, first in service and fairest in prices." (Courtesy Lake Worth High School and Clint Narmore.)

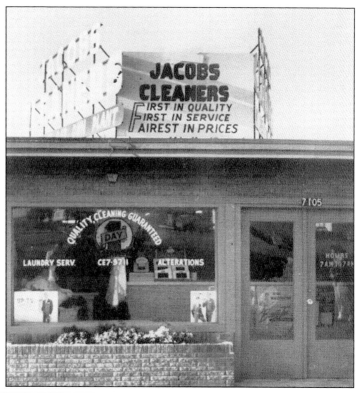

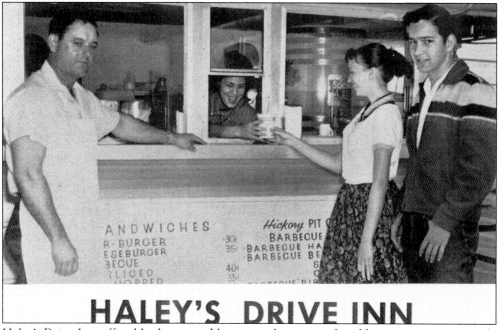

Haley's Drive Inn offered barbeque and burgers at low prices. In addition, service apparently came with a smile. The gentlemen in the photograph show what appears to be a slight bit of apprehension, whereas the young ladies look as though something really funny has just happened. (Courtesy Lake Worth High School and Clint Narmore.)

A. R. "Skinny" Pole's business was cabinet making, advertised here. With other services such as add-ons and millwork, plus the generous financial plan of no down payments and 36 months to pay, he likely stayed busy. The child is unidentified but may have been his daughter. (Courtesy Lake Worth High School and Clint Narmore.)

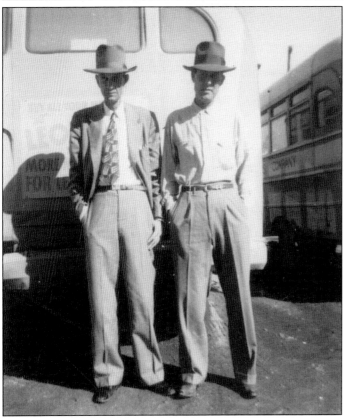

Raymond Teasley, on the left, is standing with his friend Adam Gibson behind the bus Teasley owned. He provided bus service from Casino Beach to downtown Fort Worth, a distance of 9 miles. This was during the late 1940s and perhaps early 1950s. (Courtesy Herb Teasley.)

In 1947, Lake Worth experienced a very cold winter, evidenced here by the long icicles hanging from an old rock water tower and the piled-up ice. The four young men in the photograph are, from left to right, Earl Ward, Joe Rayl, Willie Crain, and Ben Mauldin. (Courtesy Ben Mauldin.)

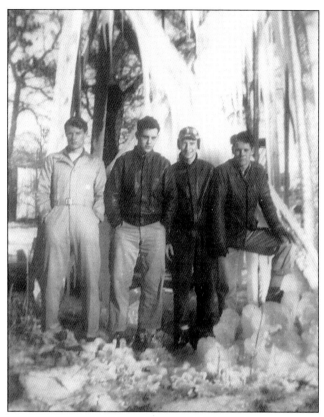

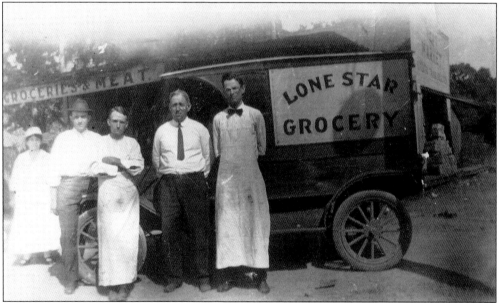

These four men standing in front of a vintage vehicle belonging to Lone Star Grocery around 1930 are unidentified, except the second from the left, James Richard "Rich" Foster, one of the early residents of Lake Worth. Foster owned a similar vehicle seen in other photographs. (Courtesy David Woodall.)

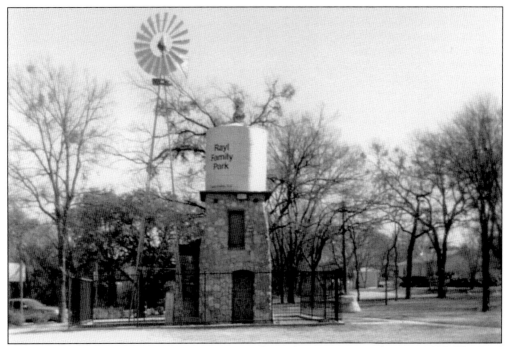

The old rock water tower in a previous picture is shown here many years later, in 2009. The Rayl family wanted to donate the property for a city park, but federal laws prohibited it, stating the land must be purchased. The city bought it at an evaluated price. Joe Rayl gave generously for the park's upkeep with continuous donations to maintain it. An outstanding addition to the area, many enjoy the several water features that enhance the landscape. (Author's collection.)

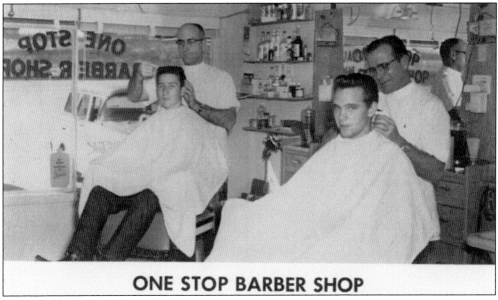

Men need grooming services just as women do, and the One Stop Barber Shop appears to be well equipped to take care of that need. The unidentified barbers seemed to be concentrating on their jobs in spite of the camera, unlike the young men who stare at the camera. (Courtesy Lake Worth High School and Clint Narmore.)

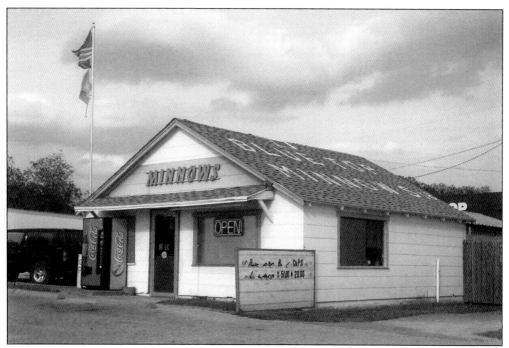

The Blue Top Minnows is the name of a business that dates back to the late 1930s or early 1940s. It stayed in the same location at the corner of Roberts' Cut Off and Highway 199 for as long as it was open. This may be the last photograph taken before the name recently was replaced with the word "Tobacco," shortly after the image was shot. (Author's collection.)

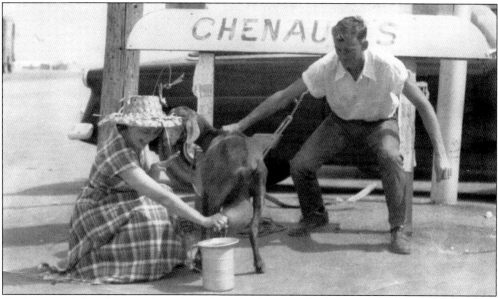

At the time of this photograph in the mid-1940s, the young lady wearing the hat and milking the goat had the name Vivian Chenault. She and her husband, Pinky Chenault, opened Chenault's, a restaurant on Highway 199, known also as the Jacksboro Highway. It was popular from the beginning, and the owner had a way with people that brought them back for good food and good company. (Courtesy Courtney and Chenault family.)

This is the restaurant Vivian Chenault owned. After she divorced her husband, she remarried a man named Bill Courtney and the name was changed to Courtney's. Fun and laughter filled the room just about anytime one went there to dine on the delicious variety of food. The property sold several years ago as Bill Courtney's health declined. (Courtesy Courtney family.)

Vivian Courtney was an outstandingly pretty young woman. Active in several organizations and clubs in her youth, she and her civic contributions were appreciated by many. She has three children—a son and two daughters—and several grandchildren. Now a widow in her 80s, she is still pretty and enjoys talking to her friends but misses her restaurant very much, as well as her recently deceased husband. (Courtesy Courtney family.)

Bill Courtney, much like his wife, enjoyed working at their restaurant, Courtney's. If he was not in the back helping with the cooking, he was out front visiting. He served tasty buffet lunches for many years, and the desserts were outstanding. Customers from all walks of life frequented the business, which had a Hollywood decor. Men particularly enjoyed discussing vintage cars with Bill Courtney, who was an aggressive car collector. He also enjoyed collecting other antiques. His slow easy drawl fit him well as he beamed with pride over his prized favorites. (Both courtesy Courtney family.)

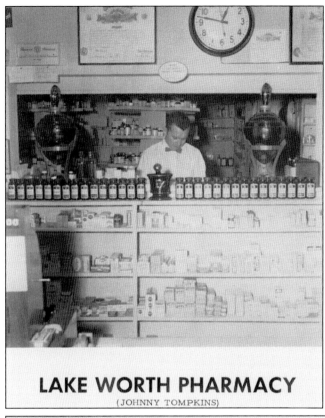

LAKE WORTH PHARMACY
(JOHNNY TOMPKINS)

Lake Worth did not have a real pharmacy until Johnny Tompkins opened Lake Worth Pharmacy. He is shown here behind the counter working. His two sons followed in his footsteps and became pharmacists also. The Tompkins family enjoyed fishing in Lake Worth, where their home was located just a short distance from the water. Both Johnny and Beulah Tompkins are deceased. (Courtesy Lake Worth High School and Clint Narmore.)

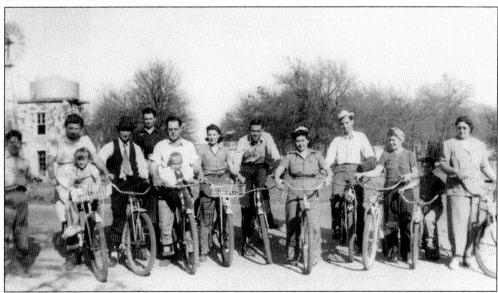

Unidentified local residents of Lake Worth who enjoyed cycling got together in the 1940s to share their love of riding bicycles by forming a club. In the background of this photograph is an old water tower and windmill, often displayed in vintage photographs of the site because of where it was located; there was space and trees, which made it ideal for many occasions. (Courtesy Jerrell Elston.)

Three

FURTHER DEVELOPMENT

In 1935, J. R. Foster, who came to Lake Worth in 1922, built a lovely seven-room rock home in the community. Some thought it the prettiest house in the whole community. Children enjoyed walking by or into the yard, for it had a fish pond, native flowers, and a birdbath. Foster's family remembers that Sunday dinners and holidays were always festive affairs in the Foster home. They enjoyed hearing the story of why Foster was born in a jail in Granbury, Texas. This was not unusual since his father, Theodore Foster, was a deputy sheriff and lived in the jail.

Many other structures of less grand style were built throughout Lake Worth during the 1930s and the following years. One of the builders is featured in this chapter, although of equal importance are those not included, such as Art Anders, who built many homes in the area.

As Lake Worth's population grew, the Boy Scouts organization had several boys receive the Eagle Scout award during the 1940s.

Not long after this, Vance Godbey opened a restaurant located on the same site as his home. After fire destroyed his home and business, he rebuilt, and over time, his restaurant became well known. The restaurant's history is very interesting and will be featured in this chapter. In addition, another type of restaurant opened serving Mexican food, cooked and served by the Arizola family, which has also become very well known in Lake Worth.

Besides the various style homes, the Boy Scout events, and wonderful eating establishments, the funeral needs of the community continued to be met by the establishment of Biggers Funeral Home, which purchased the Miller Funeral Home and renovated it.

Even with all of the aforementioned developments, a city needs so much more. In the remainder of this chapter, the Lake Worth Library is given a brief history, including its special name and its utmost importance to the city's profile. Other important parts of city growth will be discussed in future chapters.

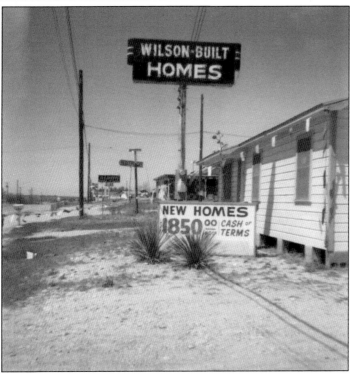

Since 1961, Billy Wilson has built homes in the Lake Worth area as well as in other counties. At one time, he offered a very reasonable plan: less than $2,000 for a shell home. Also, Wilson has served the community by working in the Kiwanis and Lions Clubs. Having served in various capacities in the chamber of commerce, including holding the presidency, he and his wife, Charlotte, have owned an insurance business in Lake Worth for many years. Charlotte runs the office now, for he does roofing and remodeling. They reside in Lake Worth. (Both courtesy Billy Wilson.)

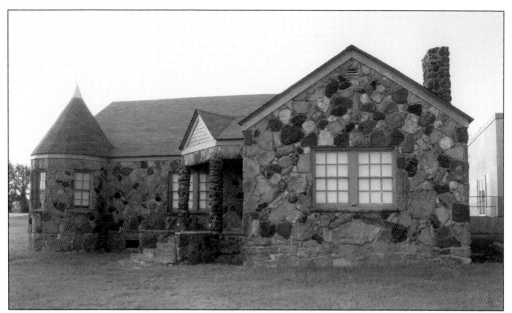

In 1935, J. R. Foster built this lovely rock house on a plot of land that resembled a park after his innovative addition of gardens and fish ponds, not shown in this recently taken photograph. The successful businessman would surely have been pleased had he known that someday his home would be chosen to become the Lake Worth Area Historical Museum. (Courtesy Jamie Woodall.)

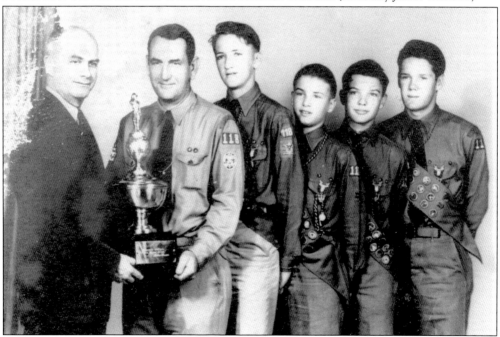

In the mid-1940s, this group of young men achieved the Eagle Scout award in the Boy Scouts of America organization, the highest award offered for successful completion of a rigorous program. Julius Bruner (left) presents the trophy to Buddy Wyman. The Eagle Scouts behind Wyman are, from left to right, Eldon Pritchard, Duane Giles, Charles McCullough, and Ben Mauldin. (Courtesy Ben Mauldin.)

Sprawled across a large plot of land, which was once a ranch, is this lovely building that started out as a smaller home. In 1955, the Godbey family lived in the back portion of the house and had a small restaurant in the front. After a fire destroyed the home, Vance Godbey built a larger structure with a massive fireplace in the living room. Situated on the shores of Lake Worth in the city of Lakeside, the site was ideal for lovely views, which included huge oak trees out front.

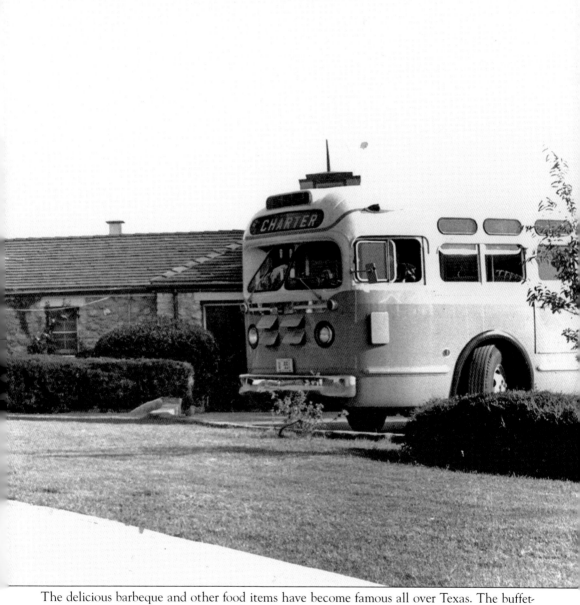

The delicious barbeque and other food items have become famous all over Texas. The buffet-style service allows one to eat generously, and each person receives friendly smiles and excellent service. The restaurant has a successful catering service in addition to the restaurant, now open only on Sundays and for special occasions. (Courtesy Carol Godbey.)

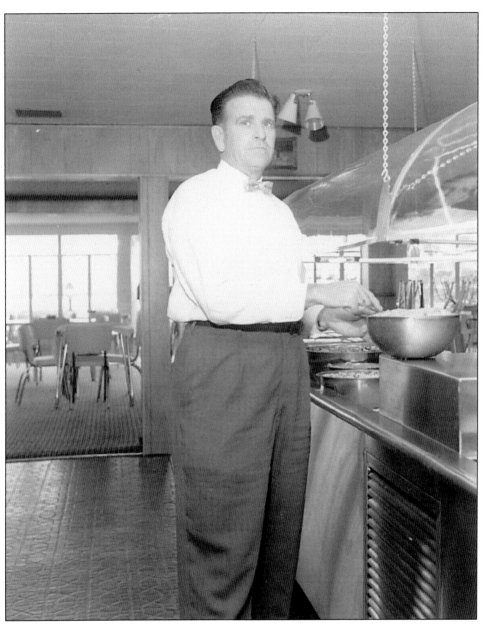

Vance Godbey came to Lake Worth in 1947. He lived in Indian Oaks on Cheyenne Trail and established a grocery in the front portion of his home with living quarters in the back. After Buddies supermarket came to the area, the competition caused the closing of the home grocery store, but soon Godbey set up a barbeque stand inside a small building on the Buddies parking lot. He closed two years later when Winn-Dixie bought Buddies. He moved his family to a location farther down Jacksboro Highway, where they lived in the back portion of the house and had a small restaurant in front. After fire destroyed the building in 1962, Godbey rebuilt a larger structure and the media carried the story to the public. His restaurant soon became famous. Godbey became well known also for his generosity. He raised large sums of money for families of fallen firefighters. At the time of his death in 2003, he had given over 300,000 pounds of meat for charities and paid for schooling for several teenagers. (Courtesy Carol Godbey.)

Vance Godbey, second from right with suspenders on, walked with a gait of confidence even in his high school days, as shown here. Long-sleeve white shirts and suspenders were popular attire during that time. Godbey grew up on the north side of Fort Worth and attended North Side High School. He graduated in 1938. (Courtesy Carol Godbey.)

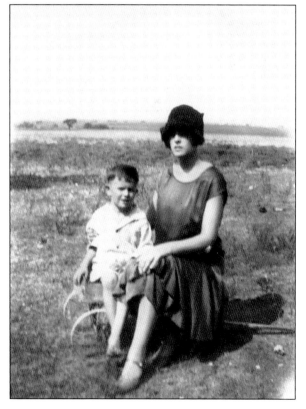

Born on August 11, 1919, Vance Godbey became a handsome toddler, seen perched here on the seat of some type of two-wheel equipment with his mother. Note the young boy's two-piece attire with the gathered puff sleeves. It is assumed the photograph must have been made in the summer because of the short-sleeve dress his mother has on and the bare feet of the youngster. (Courtesy Carol Godbey.)

Arizola's
Family
Restaurant

1910 - 1991

Mama Enriqueta Arizola prepared food and sold it from her home. She eventually needed more space. After her husband, Camilo, died, leaving her with a large family to raise, she opened her own restaurant. At the time of his death, the family lived on the north side of Fort Worth but decided to move to Lake Worth. The rock structure the restaurant occupied was originally the building where J. R. Foster had his store. After Enriqueta Arizola's death, her children continued operating the popular Mexican food restaurant, located at two different sites since that time. The last move involved remodeling an old MacDonald's restaurant on Jacksboro Highway. Angie Arizola, the widow of Enriqueta's son Ricky, still serves up delicious meals in a friendly atmosphere. (Courtesy Arizola family.)

Enriqueta Arizola taught her family how to make enchiladas and tamales. At first, she took orders for tamales and made them in her home. When the orders became too many for her to make at home, she decided to move into a building. The Arizola reputation is built on friendly and courteous service in addition to their tasty food. (Courtesy Arizola family.)

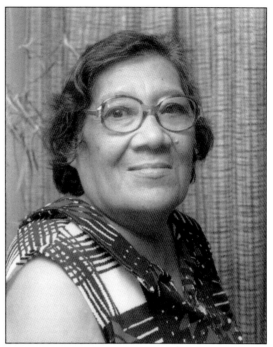

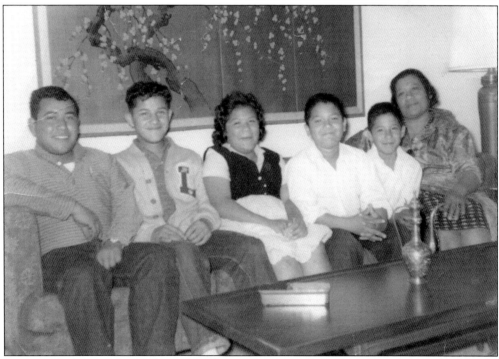

Art Arizola (second from left) was the first Hispanic football player in Lake Worth's schools. His energetic personality leaps out from this photograph. This family has engaged in worthy civic affairs in the Lake Worth area for a long while, such as community events to raise money for scholarships. Seated from left to right are Camilo Jr., Art, Rita, Rudy, Ricky, and Enriqueta Arizola. (Courtesy Arizola family.)

When Enriqueta Arizola turned 83, her family gave her a birthday party at their restaurant on Merrett Street, with many guests enjoying the event. In the middle of the photograph is Enriqueta Arizola, who is smiling, apparently pleased with the whole affair. Country western singer John McGee performed for the party. (Courtesy Arizola family.)

In this photograph, the love and closeness felt for each other is easy to see by the expressions on the faces of members of the Arizola family. Sadly, Ricky (standing, far left) died unexpectedly in 2003, twelve years after Mama Arizola's death, who is seated at far right. (Courtesy Arizola family.)

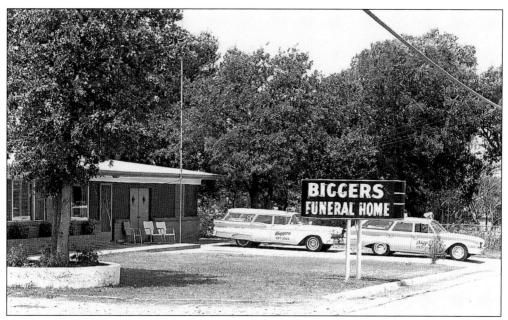

On August 15, 1957, Biggers Funeral Home opened in Lake Worth. The Biggers family purchased the business from Millers Funeral Home, which had operated in that location for five years. At that time, the employees were members of the family, and they had only one ambulance and one funeral coach. (Courtesy Biggers family.)

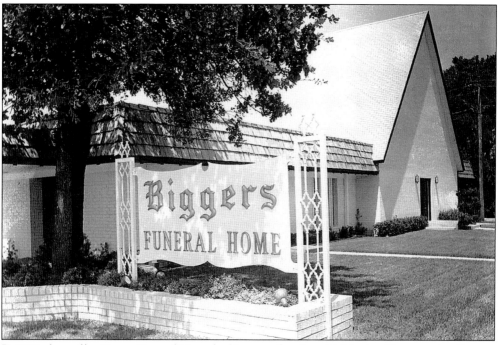

By 1971, the staff at Biggers Funeral Home had increased to six, with Maxine Biggers as the director. A large chapel was added to the original structure after the family purchased the property, which had been on lease prior to this. Local churches had allowed funerals to be held in their chapels even if the deceased person was not a member. (Courtesy Biggers family.)

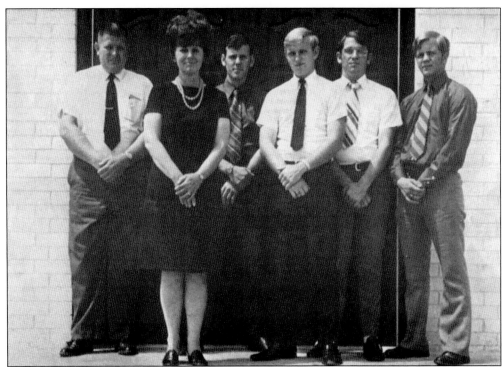

Maxine Biggers is shown in this photograph with her full-time staff in 1971. At that time, she and her son Larry Biggers were licensed morticians. Identified persons in this photograph are, from left to right, Jim Morgan, personnel manager; Maxine Biggers, owner and director; Larry Biggers; Gary Biggers; Gary Scott; and Randy Moore. Not shown in this photograph are the ambulance attendants. (Courtesy Biggers family.)

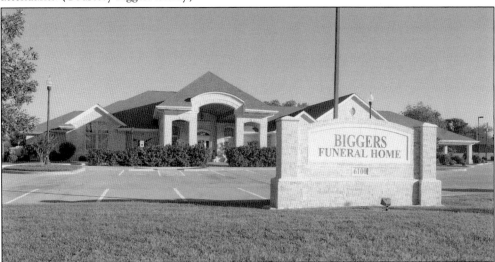

In 2006, Biggers Funeral Home moved from their Jacksboro Highway location to the corner of Azle Avenue and Boat Club Road. The same friendly family owns and operates the business in this outstanding architecturally designed structure. As beautiful on the inside as the out, the color scheme and interior design of the layout along with well-chosen furnishings offer a comforting atmosphere for those in mourning. (Courtesy Biggers family.)

For many years, those living in Lake Worth had to go to another city for library books. In 1961, a new library opened in Lake Worth with Mary Lou (Girard) Reddick as the librarian. Reddick is shown at right at the ceremony naming the library after her. Her tireless effort to gather books and catalog them provided the backbone for a small library, which has proven to be very successful. Through the years, the library has grown as new books are donated, often in the memory of a deceased loved one or friend. Books are also purchased by the library. In the photograph below, Reddick is enjoying celebrating the 10th anniversary of the library. (Both courtesy Karen Smith.)

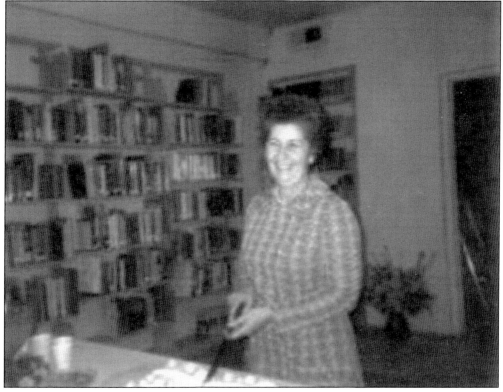

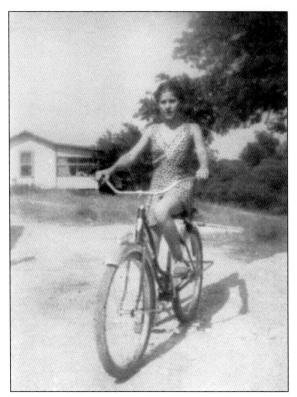

In this photograph, Mary Lou Girard is a young girl riding her bicycle on Lotus Trail in Lake Worth near her home. In the background is one of the typical small-frame homes that were built all over the community. Note the large overhanging oak tree prevalent in the area. The attire Girard is wearing and her shadow on the ground identifies this as likely a sun-filled summer day when the photograph was snapped. (Courtesy Karen Smith.)

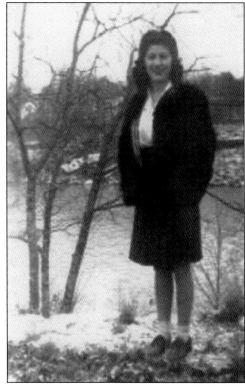

During the year 1930, Tarrant County experienced a big freeze and Lake Worth was hit as hard as the lake froze over. Mary Lou Girard, the young lady dressed in a short coat, bare legs, and without a head covering, paused long enough for her picture to be taken. It looks as though she is saying, "Hurry up, I'm freezing." (Courtesy Karen Smith.)

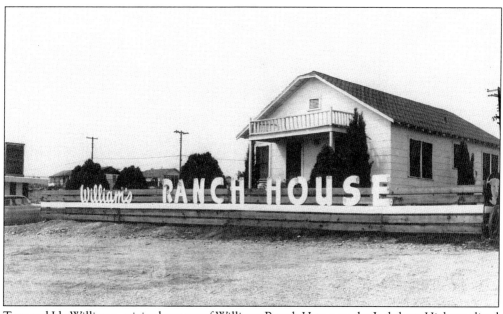

Tom and Ida Williams, original owners of Williams Ranch House on the Jacksboro Highway, lived in this house in 1954 next door to their restaurant, which involved the entire family in running the business. The couple had three sons who worked there. Dan Jr. was the oldest son, Tom was the second son, and Wayne the youngest. (Courtesy Wayne Williams.)

WILLIAMS RANCH HOUSE

Fort Worth, Texas

Desserts

Fresh Fruit Pies	.20
~~Pineapple~~ Sherbert	.15
Vanilla Ice Cream	.15

Coffee, Tea, Milk, etc.

Coffee, per cup	.10
Iced Coffee	.15
Sweet Milk	.10
Buttermilk	.10
Iced or Hot Tea	.10
Pot of Tea	.20

Side Orders

Buttered Toast	.15
Beans	.20
French Fries	.20
Onions	.10
Tomatoes	.20

The original Williams Ranch House had delicious fruit pies for 20¢ to go along with that 10¢ cup of coffee. Perhaps a whole pot of tea for 20¢ would be more satisfying. For some, enjoying a cold glass of buttermilk or regular milk would be the ultimate on a hot summer day. Items such as iced coffee, sherbet, and ice cream also were available. (Courtesy Wayne Williams.)

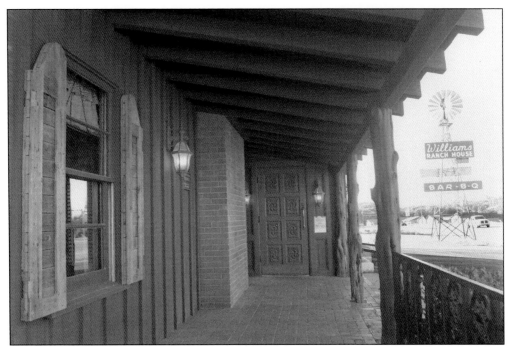

This image shows the entrance to Williams Ranch House with a better perspective of the cedar posts. The bark was stripped off to expose the beauty of the wood, as seen here. The heavy door of Spanish motif fit the time period nicely as well as enhanced the softly lit interior when one stepped inside, perhaps to enjoy a 10¢ cup of coffee with their meal. (Courtesy Wayne Williams.)

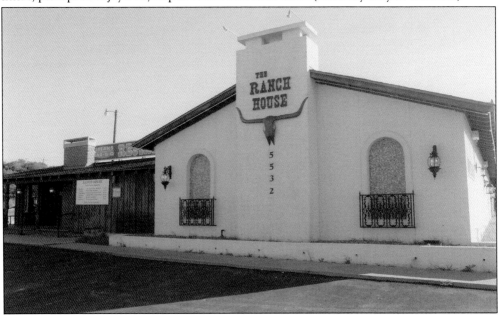

Because of increased business in 1966, the Williams family decided to enlarge the restaurant. Although there were two functional fireplaces in the structure when the stucco addition was added, a fireplace facade was included, which gave a charming balance to the overall appearance of the large building. (Courtesy Wayne Williams.)

Improvements to the Williams Ranch House included the addition of a windmill to support the sign that advertised the restaurant. The first windmill they erected was not strong enough to support the sign. After it fell, Wayne Williams brought in a better constructed one that held the large sign without any problem. (Courtesy Wayne Williams.)

Wayne Williams and his wife, Chris, both worked in the restaurant. Wayne was well equipped for this business since his family had been owners of a barbeque business when he was very young, and he had to help his mother because his father suffered poor health and his two older brothers were in the military service. Now retired, Williams enjoys flying for a hobby. (Courtesy Wayne Williams.)

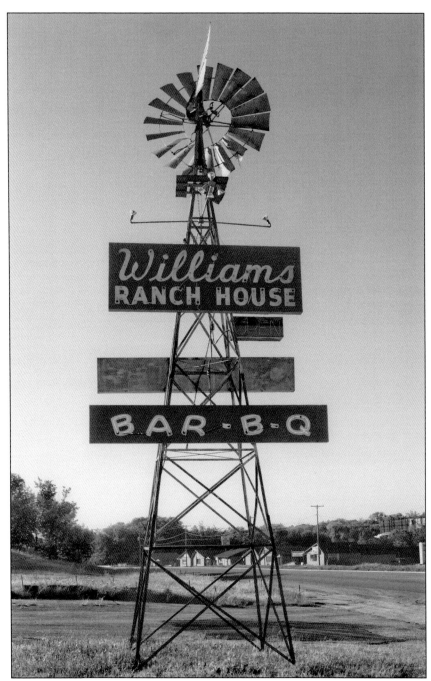

The windmill in front of Williams Ranch House has its own history in that the one shown here is the one erected after the first had fallen. Another event happened to the windmill that created a stir. One day, a driver lost control of his car and plowed into the windmill. Again the advertising sign was on the ground. Several drivers passing by and seeing the fallen windmill called to see if perhaps they could buy it. A nice but firm "no" was given. The incredible icon had become a landmark on the highway, and Wayne Williams intended to keep it that way, so it once again was stood upright for all to enjoy. (Courtesy Wayne Williams.)

Four

SCHOOLS AND CHURCHES

From the beginning, Lake Worth schools have undergone extensive growth and change, perhaps starting with a name change from Rosen Heights Independent Rural School when S. E. Watson was the second superintendent. C. C. White was the first superintendent; no photograph was available for him. Watson's photograph is included with the first graduating class. Lake Worth schools became accredited under his direction during the 1937–1938 school year. Since that time, the schools have survived fires and new buildings; grown in numbers and curriculum; and added extracurricular activities, various gyms, and stadiums.

In addition to the schools' growth, religious endeavors developed. The First Baptist Church, once called Indian Oaks Baptist, was established in 1932, not to be confused with Lake Worth Baptist, which was established in 1937. Lake Worth Baptist purchased the first old school building in Lake Worth and had it moved to its present location on Hodgkins Road. Also dating back to 1937 is the Lake Worth United Methodist Church, which constructed its first building on Merrett Street on land donated by William Charbonneau. The church met here for many years before building a new church on Azle Avenue. Years later, still a united Methodist Church, the congregation moved outside Lake Worth to Robertson Road and is now called Lighthouse Fellowship Church.

Another interesting area church that dates back to the 1940s is St. Anne's Episcopal Church located on Azle Avenue. Having met in various places before their building was completed, the church has several photographs that chronicle some of the moves. The Church of Christ also has an extensive history as three churches merged together. The Metropolitan Baptist Church dates back possibly to the 1920s, although not located at its present site. There is the possibility there are others with a long history. The author offers apologies for lack of room to display further photographs in this chapter.

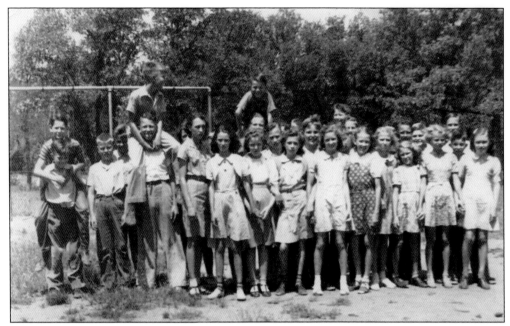

This is a group of unidentified students in the third and fourth grades in 1936 stand in front of a swing set. It appears the outdoor time brought on a lot of horseplay. Notice the very long legs of the boy on the adult's shoulders. (Courtesy Ben Mauldin.)

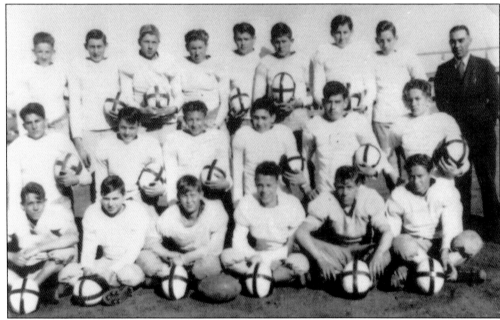

This is the first football team at Lake Worth in 1941. The boys had helmets but no real uniforms. From left to right are (first row) Leslie Elder, Bill Hull, Joe Earl Hodgkins, Floyd King, Kenneth Elder, and Neal Laverty; (second row) Jackie Rench, James Davis, Lloyd White, Gene Flory, Conway Thedford, and Buddy Williford; (third row) Carroll Doyle, Wayne Flory, Eugene "Cotton" Easley, Earl "Red" Bracken, Bill Blakey, Dorman Gresham, Earl Fowlkes, Gardner Stewart, and coach Jack Morton. (Courtesy Earl Fowlkes.)

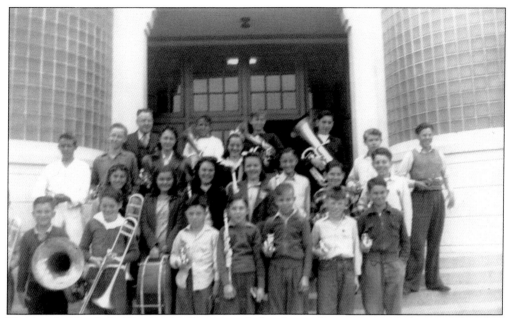

The first band at Lake Worth schools consisted of students of various ages. Only one is identified because he is in the picture and cannot remember the others. The one holding the trombone is Ben Mauldin. He is quick to tell anyone that he did not learn to play the instrument but was pleased to be part of the band. (Courtesy Ben Mauldin.)

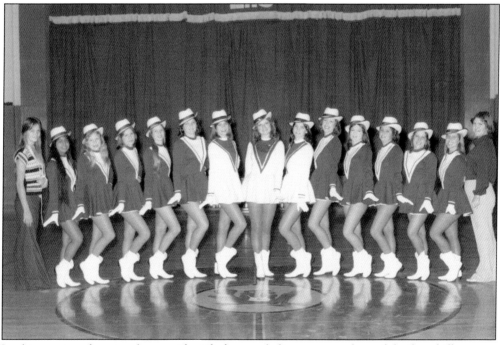

Looking pert and pretty, these unidentified young ladies were members of the first drill team at Lake Worth High School in 1977. It appears the person on the left has her arm in a sling, but it is unknown if this is a student or a young teacher; the same question goes for the person on the far right. (Courtesy Wayne and Lynn Young.)

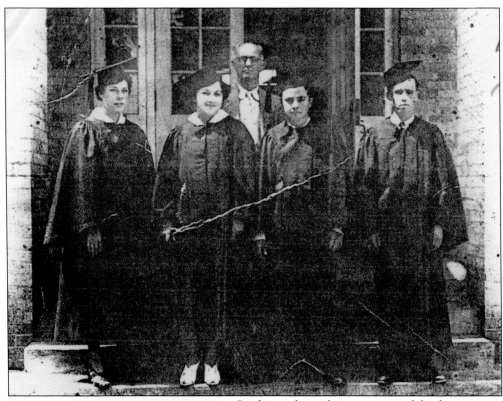

Graduates shown here are some of the first from Lake Worth High School in 1938. The superintendent, S. E. Watson, is standing at the back. From left to right are Hattie Murl Benson, Pauline Pepper, Harold Neal, and Wayne Reed. Graduates not pictured are Lucian Walls, Edwin Stillings, and Bill Weir. (Courtesy Ben Mauldin.)

Coach Frank Kring, ex–Texas Christian University star, brought leadership and pride to the teams he coached at Lake Worth during the 1940s and 1950s. He enjoyed several very successful years of coaching. The students thought highly of him and felt sadness at his early death at the age of 44. (Courtesy Ben Mauldin.)

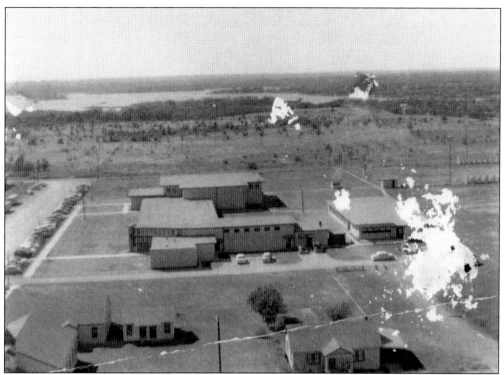

This is an aerial photograph of Lake Worth High School, which opened in 1952. The school buildings from earlier years housed the elementary students at one end and the high school students at the other. The extra space eliminated this problem. The school later had to be torn down because of foundation problems. (Courtesy Beth and Paul Harmon.)

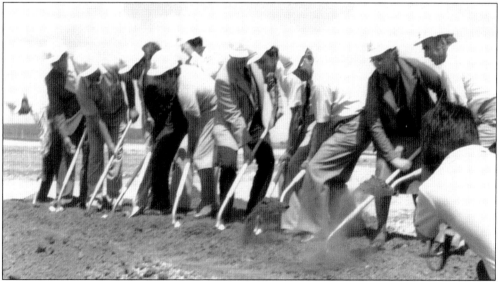

Hard hats and new shovels are used in this photograph as dignitaries and others turned up the first soil at the next new high school's ground-breaking in the early 1980s. On Boat Club Road, the work was about to start when this photograph was taken. Today that same school is undergoing a renovation with a large addition. (Courtesy Wayne and Lynn Young.)

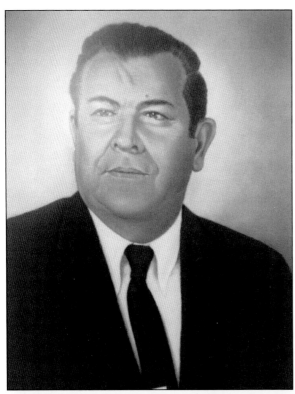

Drew Smith coached both boys' and girls' basketball. Under his coaching directions, the boys won state championship twice. One of the present high school gymnasiums was named after him years ago, as it was often the custom for Lake Worth schools to honor outstanding sports-related personnel in such a way. (Courtesy Wayne and Lynn Young.)

Kit Kittrell, a teacher and coach, inspired the lives of many students and parents. He is shown here at the ribbon cutting of the new stadium named after him in the early 1980s. The stadium is situated next to the high school on Boat Club Road and has aluminum seats capable of seating 2,400 people, a nice press box, two concessions stands, and restrooms. (Courtesy Wayne and Lynn Young.)

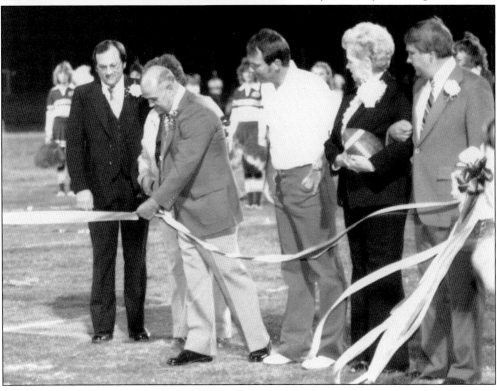

Lucille Collins, right, stands with her son, Rip Jr., and his wife and child, names unknown. Rip Collins Sr. had a gymnasium named after him; it was located next to what was at one time an underground school, built to offset noise from planes flying overhead. It is now where the Lake Worth Administration building is located. (Courtesy Wayne and Lynn Young.)

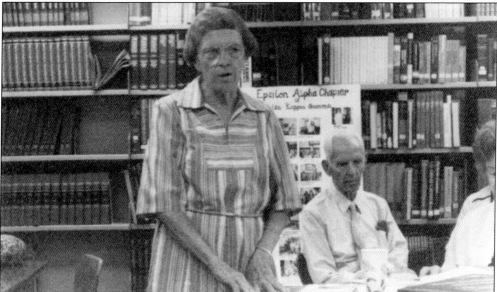

Effie Springfield Morris had a teaching career of 53 years, 45 of them in Lake Worth. Her firm but fair ways with the students made her a legend even before she died. When she was 90 years old, she gave historical information and school-related pictures to a former student. After her death, other historical information and pictures were destroyed by an unknown person. (Courtesy Wayne and Lynn Young.)

Dr. Janice Cooper is shown here. She is the present superintendent of Lake Worth Independent School District. Her educational achievements are many, as is her list of promotions, including being a principal at one time. Her tireless efforts to bring up the school district's academic standing are evident in the continuing improvement of the students' work. (Courtesy Janice Cooper.)

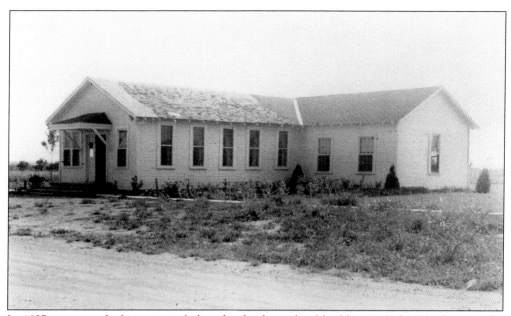

In 1937, a group of religious people bought the first school building in Lake Worth to use for worship services. The church was called Lake Worth Baptist Church. The building had been donated in 1921 by James Hodgkins for a school. After the purchase, the building was moved to the church's present location on Hodgkins Road in Lake Worth. (Courtesy Jerry Locke.)

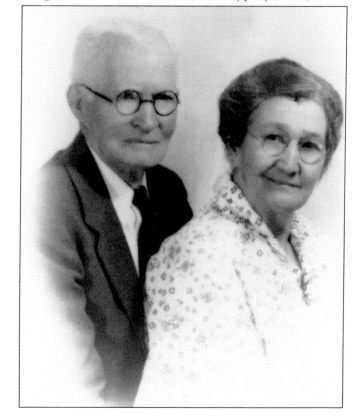

The first pastor of Lake Worth Baptist Church was Jerry L. Davis. He married Jessie Hancock at the age of 26. Together, they raised 10 children. In the beginning, Davis was a pharmacist, but around 1900, he began his ministry studies at Howard Payne College in Brownwood. He was 74 when he founded this church in 1937. He served until his resignation in 1941. (Courtesy Jerry Locke.)

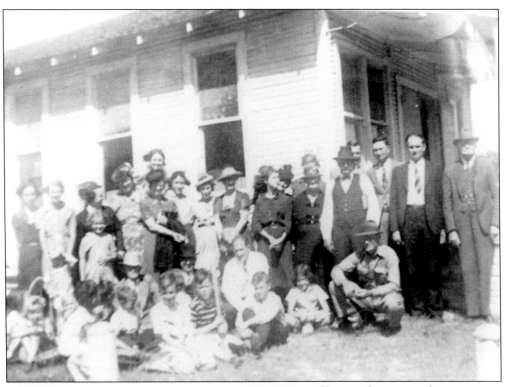

Twenty charter members were registered for Lake Worth Baptist Church. They were Mr. and Mrs. M. L. Benson, Mr. and Mrs. H. G. Cole, Mr. and Mrs. Davis, Mr. and Mrs. B. H. Davis, Mr. and Mrs. J. L. Davis, Mr. and Mrs. J. D. Halbert, Mr. and Mrs. O. D. Halbert, Mr. and Mrs. J. R. Hammonds, Harriett Latham, Mr. and Mrs. L. W. Pope, Virginia Ray, and unidentified children. (Courtesy Jerry Locke.)

Jerry Locke married Susan Lee in 1966 at the Lake Worth Baptist Church. In June 1983, he became the sixth person to pastor Lake Worth Baptist Church. Locke holds several degrees relating to the ministry, including a bachelor of theology, a master's of divinity, and a doctorate of ministry. (Courtesy Jerry Locke.)

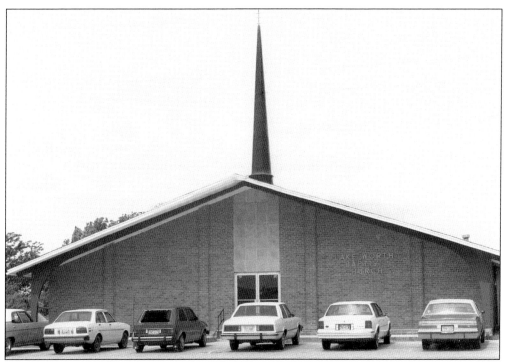

The present Lake Worth Baptist Church is shown here. For many years, Al C. Locke Sr. pastored this church, and during his service, there were five major building programs, including a parsonage. He retired in 1983 and moved to Dublin, Texas, where he lived at the time of his death in 2003. (Courtesy Jerry Locke.)

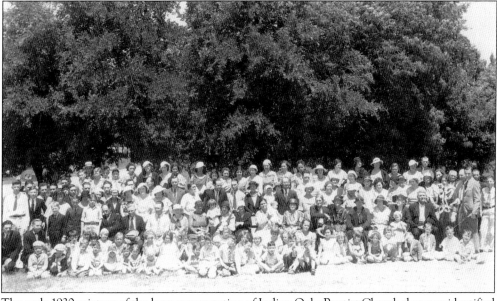

The early-1930s picture of the large congregation of Indian Oaks Baptist Church shows unidentified members standing and sitting with a lovely backdrop of what must have been very green live oak trees, since there are many in the area of their church. There appears to be a large number of youth in attendance. (Courtesy Jerrell Elston.)

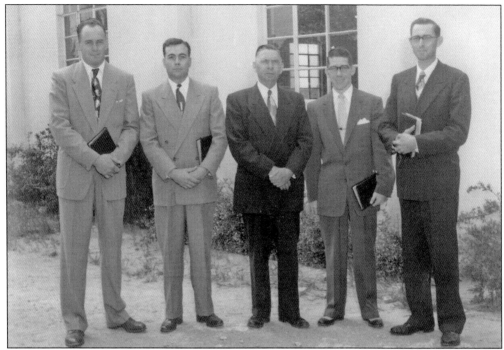

The year 1953 was a good year for Indian Oaks Baptist Church, later known as First Baptist Church Lake Worth, for several members became ordained ministers, shown here holding their Bibles. From left to right are Ferrin Perkins, Ben Averyt, Tony Lewis, Jerrell Elston, and Wayne Flory. (Courtesy Jerrell Elston.)

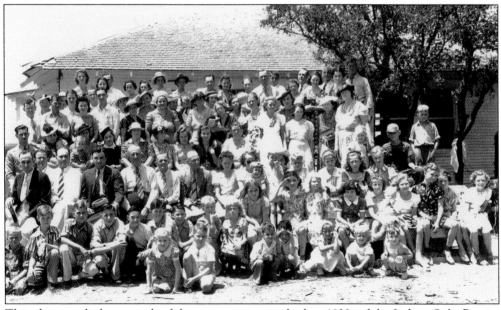

This photograph shows much of the congregation in the late 1930s of the Indian Oaks Baptist Church, later called First Baptist Church. Because of a shortage of space, some early Sunday classes were held in a dugout. Note this is a different church than Lake Worth Baptist. The large oak tree in the background stands majestically beside the church building. (Courtesy Jerrell Elston.)

In 1997, First Baptist Church Lake Worth celebrated their 65th anniversary. The church not only serves the community with worship services but currently allows the senior citizens to meet there in the interim period of waiting on a new building to be constructed near the future Historical Lake Worth Area Museum. (Courtesy Gary Goodman.)

The Lake Worth United Methodist Church was established in the Lake Worth area in 1937. This building was constructed on a plot of land on Merrett Street donated by a member, William Charbonneau. The first Sunday school classes were held in a fishing camp at Mosque Point Park. The church building is now owned by an individual who leases it to another church group, called Open Arms Fellowship. (Courtesy Ben Mauldin.)

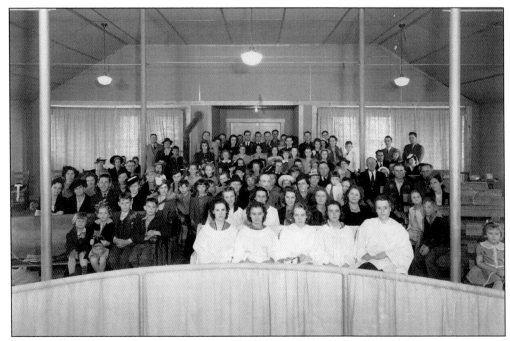

These unidentified people inside the Lake Worth United Methodist Church, when it was located on Merrett Street, appear happy in this photograph with a small choir seated in front behind a skirted area. Notice the old stove pipe running up the wall in the back, obviously from a wood-burning heater of some sort. (Courtesy Ben Mauldin.)

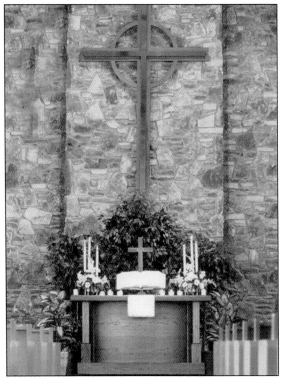

The Lake Worth United Methodist Church, the interior shown here, was among several churches located on Azle Avenue. After a long while, the church outgrew the facilities and sold the building in 2004. Forty acres were purchased just outside Lake Worth's city limits, and temporary services were held elsewhere. A new building was constructed in 2006, incorporating the beautiful cross into the interior design. (Courtesy Lighthouse Fellowship Church.)

Just as lighthouses guide ships to a safe harbor, Lighthouse Fellowship Church strives to bring in people from everywhere to worship with its beckoning lighthouse atop the new building. Another of the unique things in this new building is a social place called Hebrews Café. Free coffee and other beverages as well as food are served here to members and guests. (Courtesy Lighthouse Fellowship Church.)

Frank Briggs, shown here, is the current pastor of Lighthouse Fellowship Church, formerly Lake Worth United Methodist Church, where he became pastor in 1990. Before that, he was associate pastor in Arlington at St. Barnaba's Church. Pastor Briggs's education includes a master of divinity degree from Southern Methodist University. He and his wife, Kris, have two grown sons, Jeremy and Nathan. (Courtesy Lighthouse Fellowship Church.)

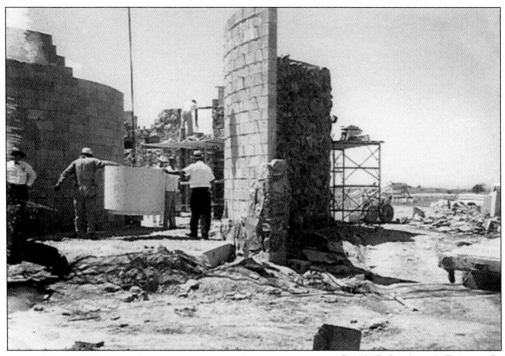

In 1965, St. Anne's Episcopal Church located on Azle Avenue was photographed while under construction. Several men can be seen working. Two of them are guiding the crane-held vat, which was probably filled with either cement or mud. Note the rounded wall made of beautiful stone. (Courtesy St. Anne's Episcopal Church.)

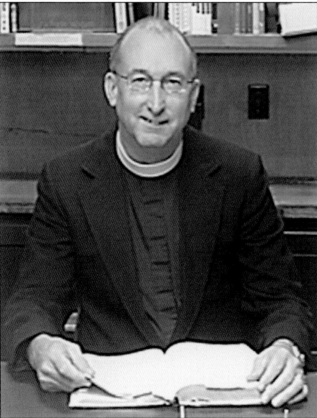

Worship services for St. Anne's Episcopal Church were held in various places while waiting on the new building to be constructed. Also, over the years, several ministers have pastored the church. At present, Fr. Roger D. Grist (shown here) ministers to the congregation. The church generously allows various groups to meet in the building. (Courtesy St. Anne's Episcopal Church.)

The three beautiful bells in front of St. Anne's Episcopal Church are shown here mounted on the rock tower, which also has an attached cross. Father Grist currently ministers to the church. The lovely building has undergone building changes from time to time to bring it to its present appearance. Tall, lush trees and shrubbery also enhance the structure. (Courtesy St. Anne's Episcopal Church.)

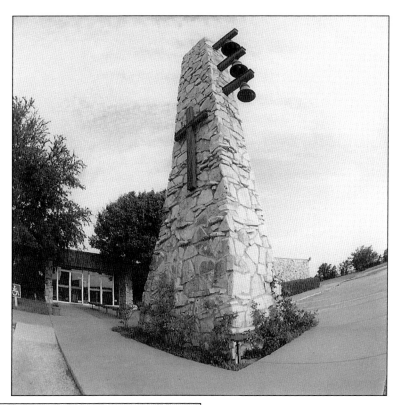

Church of Christ

at

Lake Worth

7120 Charbonneau
Fort Worth 14, Texas
Phone CE 7-2571

Lake Worth Church of Christ was at one time located in the heart of the Indian Oaks division of Lake Worth on Charbonneau Street. At that time, the church had a Fort Worth mailing address. The church eventually merged with two other nearby congregations to form the Northwest Church of Christ. (Courtesy Northwest Church of Christ.)

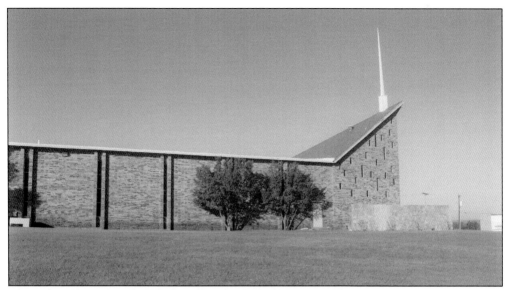

This is how the present Northwest Church of Christ appears. The building is situated on a hill at the corner of Boat Club Road and Azle Avenue. Out front, near the street, is a message board that has become an icon with messages for those passing by on foot or by vehicle, offering words of encouragement as well as Bible scriptures. (Courtesy photographer Ken Brower.)

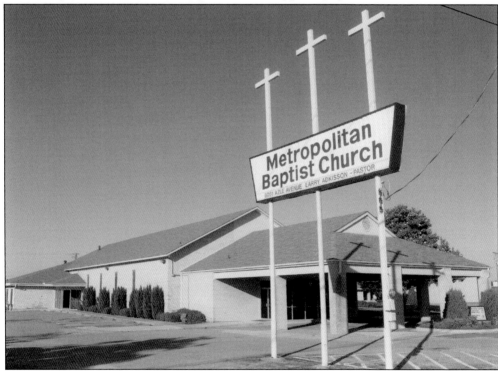

The Metropolitan Baptist Church is believed to date back to the 1920s, although it was not established at its present location on Azle Avenue but in a north-side location. This church also has a message board out front, usually with information about the upcoming services. The large parking lot is often filled on Sunday mornings. (Courtesy photographer Ken Brower.)

Five

NECESSARY DYNAMICS

Many aspects of developing, protecting, and maintaining the community surrounding Lake Worth are explained in this chapter. Early park department maintenance programs used trucks such as a vintage International truck, displayed on the next page. Several parks and picnic areas are scattered around Lake Worth and are under the care of this department.

After the Depression of the late 1920s and early 1930s, government programs developed such as the Civilian Conservation Corps, which gave housing, clothing, food, and jobs to men needing work. An aerial view included in this chapter gives an idea of the layout of one of these camps. Through the work of this program, numerous camps, shelters, or pavilions were constructed on the shores of Lake Worth.

After the Lake Worth reservoir was constructed, it became necessary to provide protection for boaters and swimmers through the lake patrol and a small police department in Lake Worth. Constables also helped to enforce laws in Lake Worth. Early fire protection and other emergency situations were addressed in the early 1940s by turning on a light attached to the top of a water tower in what was then called Lake Worth Village to summon the police or other emergency services.

With a war looming ahead, Pres. Franklin Roosevelt ordered rapid increase in peacetime war materials. Due to Amon G. Carter's research and persuasive tactics, the government chose the shores of Lake Worth to build a defense airplane and air training facility. This defense plane and base have undergone different name changes over the years. Some names are shown in photographs or mentioned in captions. The community of Lake Worth changed their lifestyle to meet the demands of the war as did the whole nation.

During the 1950s, improvements were made to the dam at Lake Worth as just another part of the necessary dynamics involved in the survival of this lake and the nearby communities.

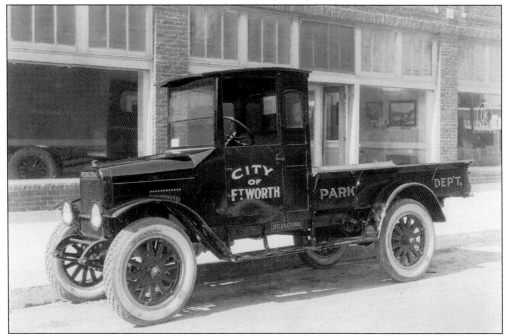

The City of Fort Worth's park department used trucks such as this. The high-pitched seat of this International truck necessitated a running board along the side for passengers to climb into the vehicle. This model appears to be from the late 1920s or early 1930s. There are several areas around the Lake Worth reservoir that fall under their care. (Courtesy Genealogy, History, and Archives Unit, Fort Worth Public Library.)

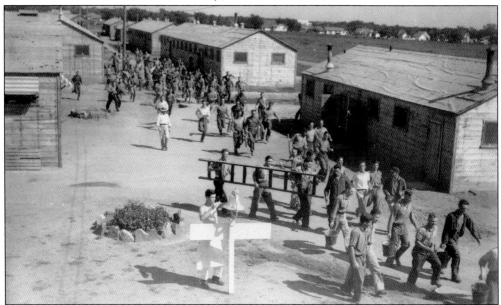

The U.S. government created programs such as the Civilian Conservation Corps (CCC) after the Great Depression to provide jobs for the many unemployed. These men, such as portrayed here, built several pavilions and shelters in the park areas around Lake Worth in addition to sometimes having to rebuild structures damaged by fire or other events. (Courtesy John Degroat.)

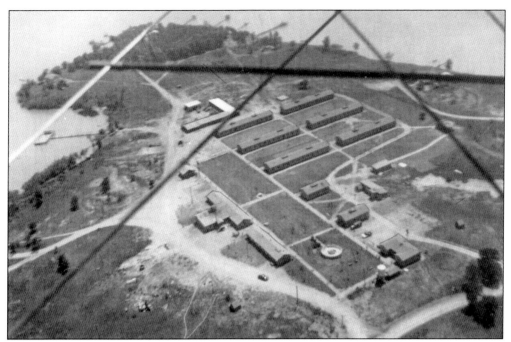

One location for a Civilian Conservation Corps camp was at Lake Worth, Texas. Men were provided housing, clothing, food, and jobs at these camps during the Great Depression. This aerial view provides a good image of the layout of such camps. Several of their work projects still stand. (Courtesy John Degroat.)

This photograph of Dutch Carroll standing by his police car was made sometime in the early 1930s. Carroll was a lake patrolman at Lake Worth, hired by the City of Fort Worth since Fort Worth owns the reservoir. Notice the tall windshield and the long-necked steering wheel on the vintage automobile. (Courtesy Don Carroll.)

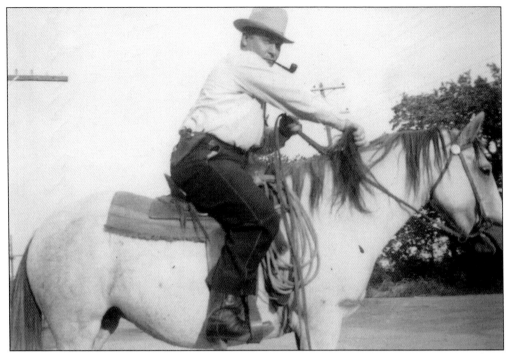

One of the early constables in the 1940s was Carl Short, shown here in his white hat and smoking a pipe. Astride his white horse with a gun strapped on plus a rope hanging from the horn of the saddle, he looks ready for just about anything that might need corralling. (Courtesy Beverly Short Burd.)

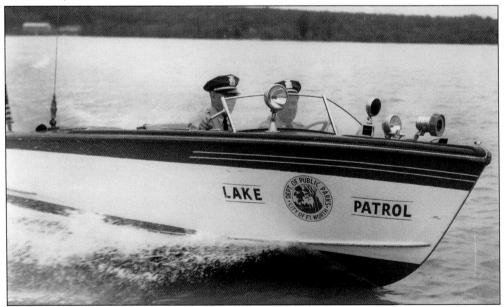

The patrolman on the left is Dutch Carroll sitting next to Constable Paul Meador. Note the information on the side of the boat indicating that the Lake Patrol was part of the public parks department of Fort Worth. With the many thousands of people frequently visiting Casino Beach, the gentlemen had plenty of work. (Courtesy Don Carroll.)

In the early 1950s, Harry Beason Jr. was the first police chief of Lake Worth, Texas. He is shown here hugging a two-year-old child he rescued from drowning in Lake Worth. Chief Beason sprinted 20 feet to dive into the morning waters to save the tot, Terry Lee Hammond. After Chief Beason gave him artificial respiration, the child recovered from the terrifying experience. (Courtesy Harry Beason Jr.)

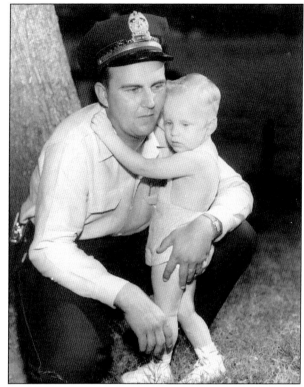

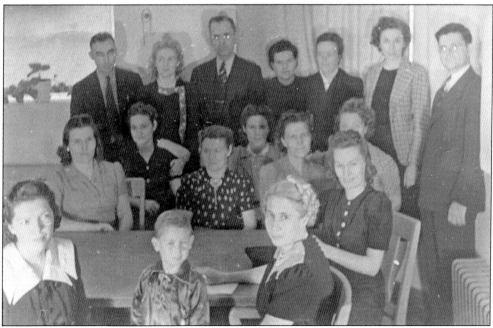

Lake Worth Schools were fortunate to have a Parent-Teacher Association early on. This photograph was made in the late 1930s or early 1940s. Most of the people shown here are unidentified except for the lady at the lower left. She is Mozelle Mauldin. She also helped in the lunchroom. Her husband, Ford Mauldin, was at one time principal at Lake Worth's school. (Courtesy Billy Caldwell.)

Although the first firefighting equipment was limited, it included this vintage vehicle as well as several other later models over the following years. The first fire truck was a Reo tank truck purchased for $500 from the City of Fort Worth in 1948. The Lake Worth Community Club spearheaded this important project. (Courtesy Lake Worth Area Historical Society.)

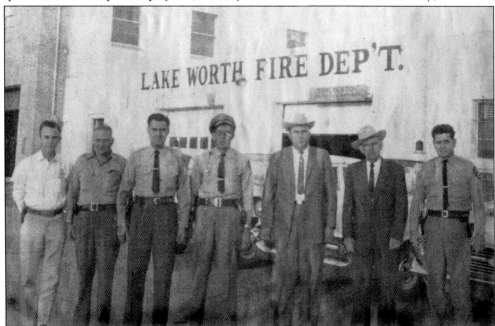

In this photograph, taken in the 1960s, are important people to the city of Lake Worth. From left to right are Eddie Bell, police and fire dispatcher; Herman Miller, fire and police dispatcher; Paul Meador, constable in Tarrant County; Bill Westbrook, Lake Worth policeman; Harry Beason, district attorney investigator; O. D. Carroll, Lake Worth lake officer; and George Campbell, Lake Worth police chief. (Courtesy Harry Beason Jr.)

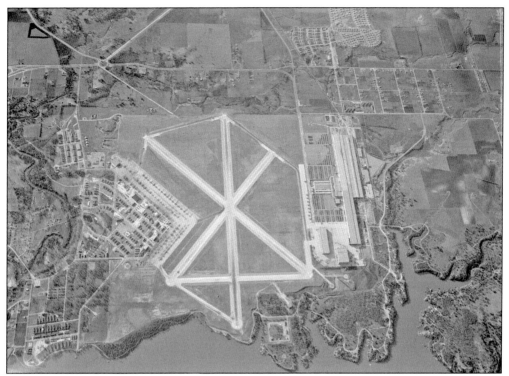

This is an aerial view of Carswell Air Force Base, which was at first an airfield for training pilots during World War II. Many world-famous B-36 airplanes were housed at this base. The planes were made at nearby Convair, which has had several names but is now Lockheed Martin. (Courtesy Lockheed Martin.)

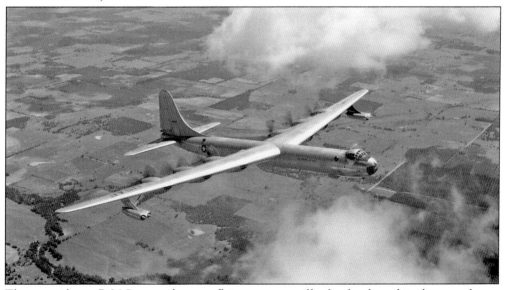

The magnificent B-36 Peacemaker was flying among puffy clouds when this photograph was taken. The enormous wingspan and long body with six engines, as well as the tail design, create an outstanding subject for this view. Perhaps another B-36 flying nearby had a photographer on board who took advantage of the beautiful sight. (Courtesy Lockheed Martin.)

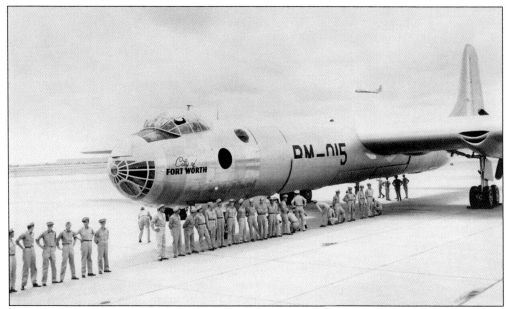

This B-36 bomber is the first one delivered to Carswell Air Force Base in the late 1940s or possibly 1950. It was the first six-engine military plane with a range three times greater than the B-29 Superfortress. The B-36 became known as the Peacemaker with its mighty capabilities that posed a threat to enemies. (Courtesy *Fort Worth Star Telegram* Collection, University of Texas at Arlington; Amon Carter Archives.)

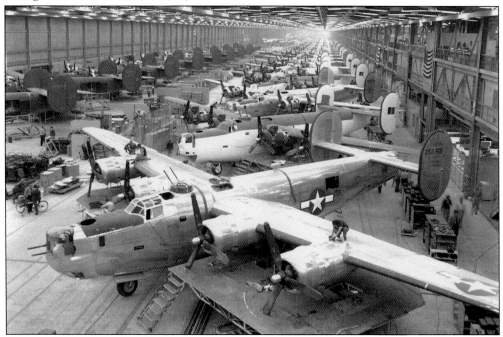

The B-24 is shown here in a double assembly line in production at Consolidated Vultee Aircraft Corporation during March 1944. Notice the guns assembled near the right wing behind the cockpit area on top and projecting out from the front part of the plane. This plane became known as the Liberator. (Courtesy Lockheed Martin.)

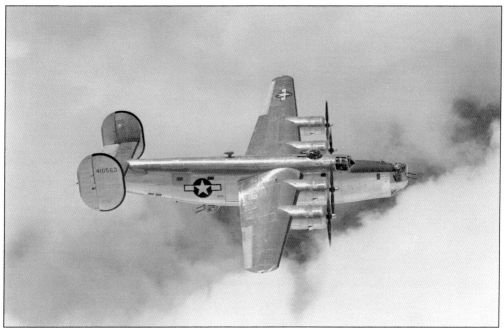

B-24 airplanes were low-level bombing aircraft. During World War II, 200 Liberator planes smashed Hitler's eastern oil supply and downed 51 of their planes in a dramatic 60-second raid. The *Eagle*, a Convair newspaper, reported this plane as one of the largest of its kind built by Convair in 1943. (Courtesy Lockheed Martin.)

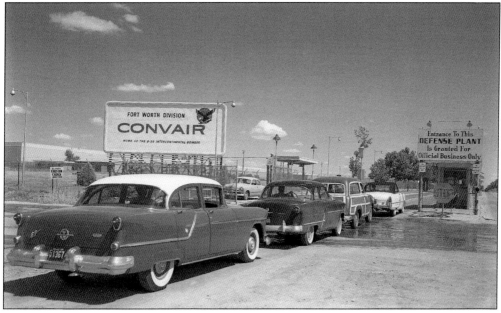

In this January 1952 photograph is one of several names the Fort Worth Defense Plant has been known by—Convair, shown on the entrance sign near the main gate. The plant was built on the shores of Lake Worth before World War II and has provided employment for many. Note the interesting cars entering the security gate, some of which have become vintage car collectors' delights. (Courtesy Lockheed Martin.)

General Dynamics is another name given to the defense plant in Fort Worth. Many used to refer to it as "GD." This photograph was taken in October 1961 of the entrance gate, which appears to have better lighting and a more contemporary sign than the photograph of the plant when it was Convair. (Courtesy Lockheed Martin.)

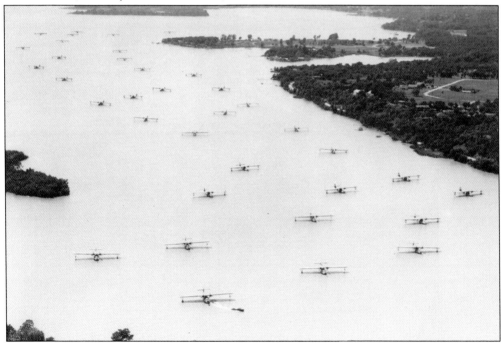

These twin-engine Navy Air Force PBY flying boats rest on the surface of Lake Worth after coming in from the coast to escape a brewing storm. Amon Carter was responsible for convincing the government to use Lake Worth as a safe haven for the planes. Carter never wanted Dallas to get credit for something Fort Worth could do. (Courtesy John Degroat.)

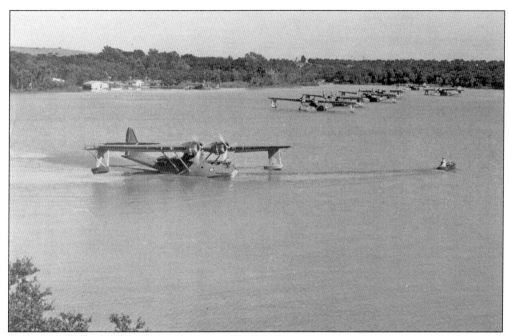

A close-up view gives a better perspective of the size of the Navy Air Force PBY flying boat if one compares it to the boat at right in the photograph. A considerable distance is shown between the planes. A boat club is possibly in the background, used as an office relating to these planes. (Courtesy John Degroat.)

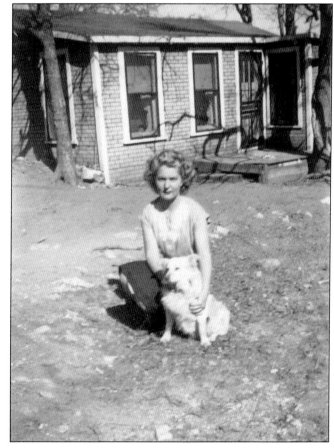

Small cottages like the one shown here were economic and common throughout Indian Oaks for many years. Some remain, but most have been torn down, relocated, or undergone extensive renovation. Shown here is Beverly Short Burd in front of a friend's house. Her father, Carl Short, was one of the early constables in the area. (Courtesy Beverly Short Burd.)

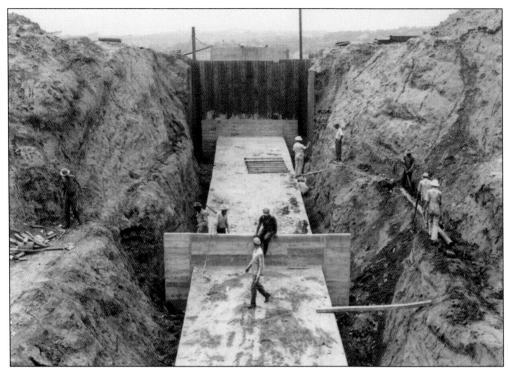

From time to time, the Lake Worth reservoir requires changes in order to maintain it. In 1950, important improvements were made to the dam. In this photograph, looking toward the lake, the steel sheet cutoff wall can be seen in the corner of the dam in the background and the concrete curtain in the foreground. (Courtesy Charly Angadicheril, Water Department Production Division, City of Fort Worth.)

This photograph shows the Lake Worth Channel improvements of October 1956. City manager J. Frank Davis is standing near the south end of the new channel and levee. To the left are about 200 acres of swampland prevented from flooding by the new channel and low levee. (Courtesy Charly Angadicheril, Water Department Production Division, City of Fort Worth.)

Six

GANGSTERS, LEGENDS, AND LORE

As Lake Worth developed from a small unincorporated village to an incorporated city, more businesses, homes, and schools developed. Unfortunately, at the same time, major crime involving gangsters and gamblers boggled the minds of citizens and lawmen. Elston Brook, an author and respected commentator, wrote in his book *Don't Dry Clean My Blackjack* about the dangerous world where well-known gamblers and gangsters lived. The reports surrounding that era indicated 16 murders had been committed between 1940 and 1960.

To the dismay of Lake Worth citizens, those happenings often occurred on the fringes if not actually in Lake Worth. Time would soften but never erase the memory of this time period. It is understandable why many felt relief when these major criminals either killed each other off or were done in by the law.

If crime did not hold the attention of citizens, incidents pertaining to World War II did. In Lake Worth, many believed that German spies were living in the area, as evidenced by belongings found by a resident next to an old water tower after the renters suddenly disappeared. Short-wave radios and papers were left behind in the attic, indicating a hasty exit. Also, local children had been given free guitar lessons by a strange man at the home of one of the children located near the lake. After he was caught making pictures of the defense plant and airbase, he suddenly no longer gave the guitar lessons. It was at that time the house near the water tower, a great lookout station, suddenly became vacant.

Further incidents that brought fame to Lake Worth were the sightings of what some believed to be a water monster. Others believed a goat man existed on a small island in the lake. Years later, an unidentified grave that gave indications a Native American princess was buried there was discovered. Also, according to legend, a rock house full of fossils was supposed to have been built over a Native American burial ground. Lake Worth's history is varied, but a true account must include the criminals and the other unusual happenings.

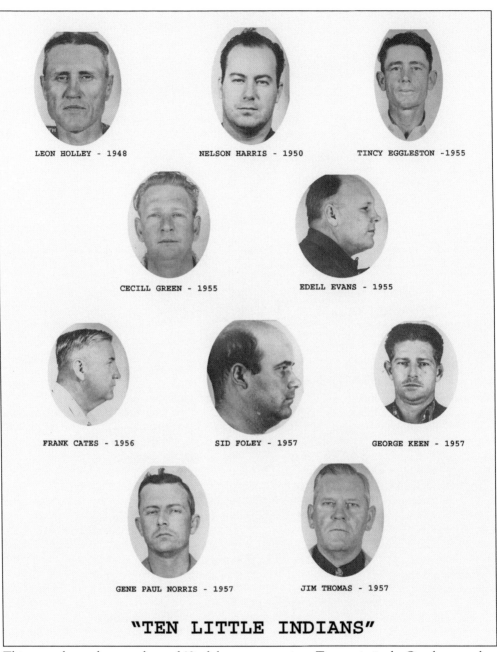

LEON HOLLEY - 1948 NELSON HARRIS - 1950 TINCY EGGLESTON -1955

CECILL GREEN - 1955 EDELL EVANS - 1955

FRANK CATES - 1956 SID FOLEY - 1957 GEORGE KEEN - 1957

GENE PAUL NORRIS - 1957 JIM THOMAS - 1957

"TEN LITTLE INDIANS"

This page shows the mug shots of 10 of the most notorious Texas criminals. One by one, they either killed each other or were killed by law officers. Their names and death dates are printed under their photograph. Elston Brooks dubbed this group the "Ten Little Indians." This is not in anyway meant to be a racial comment but is just a rendering of what was written years ago. Perhaps the most horrifying death occurred for Nelson Harris and his pregnant wife, Juanita, when their car exploded from a car bomb. (Courtesy Fort Worth Police Historical Association, Dale Lee Hinz, trustee.)

Pinball machines and marble machines brought lots of money to roadside backrooms in the 1940s and 1950s. Some restaurant owners had backrooms to hide the machines, while others were placed in basements. Always popular, these machines were sometimes seized and destroyed, as in this picture, where an unidentified officer is smashing the machine to pieces. (Courtesy Fort Worth Police Historical Association, Dale Lee Hinz, trustee.)

In this gruesome photograph, unidentified officers carry away the body of Tincy Eggleston, a gangster, according to a retired detective. The group appears to be walking uphill on a grassy slope at nighttime. Such scenes became all too common during that dreadful time period of gangsters killing each other or innocent persons during the 1940s and 1950s. (Courtesy Fort Worth Police Historical Association, Dale Lee Hinz, trustee.)

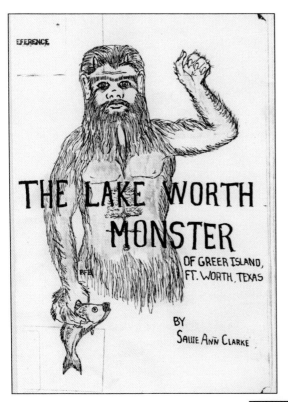

The year 1969 brought terror and likely a big hoax to Lake Worth. Only this grainy photograph of a creature emerging from the swampy area of Greer Island is known to exist. A local artist captured the essence of the beast for the front cover for Sallie Ann Clarke's book titled *The Lake Worth Monster*. The man who shot the white, fluffy-looking photograph was Allan Plaster, who reportedly laughed at the whole incident years later. He indicated that people did not use very good judgment when they carried guns with so many looking for the monster. This monster scare, or some called it monster fever, lasted for over two months as folks looked for the "Bigfoot of Texas." (Both courtesy Robby Burd.)

Greer Island is about 34 acres connected to the mainland by a quarter-mile narrow trail. It is here that some believe a monster standing 7 feet tall was seen in the summer of 1969. The description indicated the thing to be half goat, half man with white shaggy hair. With heavy undergrowth, the island is perfect for concealment. Most believe it to be an elaborate hoax. (Courtesy Dona Stuard.)

This house is made of stone most likely from Palo Pinto. Many fossils are embedded inside the walls of this structure, constructed in the late 1930s, as well as in one of the bedroom's fireplace surround. The owner was told it was built over a Native American burial ground. She has experienced a few unexplained happenings she attributes as possibly related to this fact. (Courtesy photographer Ken Brower.)

Standing majestically behind a shopping strip, this beautiful live oak tree is well over 100 years old. At one time, controversy surrounded the tree as some wanted it to be fenced off for protection. The tree has a rich legacy; a local resident has said her great-grandfather told her stories about how Native Americans used to enjoy gathering under the tree to rest and talk. (Author's collection.)

Dona Stuard (left), police chief Brett McGuire (center), and an unidentified person dig as they search for a tombstone an older resident remembered seeing as a young boy. The grave is believed to have been where a Native American princess was buried. The exact location is being kept a secret to prevent further disturbance. (Courtesy Earl Fowlkes.)

Grown into the trunk of this tree is part of a wire fence, which circled the grave site of a Native American princess buried in the area. A group of local residents belonging to the Lake Worth Area Historical Society searched until they found the spot as remembered by a man in his 80s, who joined in the search. (Courtesy Earl Fowlkes.)

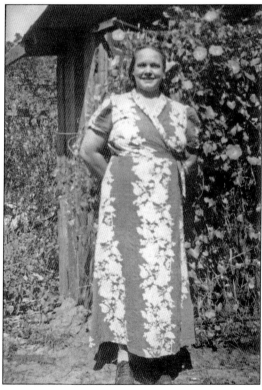

This lady is standing in front of Lake Worth resident Johnnie May Short's fancy outhouse. Inside, a person could sit on one of two places and choose from reading material on the walls as well as a Bible. Dainty curtains covered the windows, and outside flowers spilled across the roof. At the beginning of the brick pathway leading to the structure was a sign that read "Heaven." (Courtesy Beverly Short Burd.)

This handsome fireplace once stood inside a large home in Lake Worth. Nearby is evidence of the remains of a basement for the home. The property has large oak trees and now has three small modern bungalows several hundred yards from the lovely old fireplace. Longhorn cattle also share this interesting piece of property. (Author's collection.)

Frank Riley owns a unique piece of property in Lake Worth where a mansion once stood. He also owns land where a nightclub called the Goon, probably dating back to the Victorian period, was located. Granite steps leading up to the property from the street still stand. (Author's collection.)

Seven

SPECIAL INTERESTS, PAST AND PRESENT

From the small community of Lake Worth, many have succeeded in honorable professions. The James Hodgkins family, Charbonneau, and the Foster family are three of the former residents who greatly influenced Lake Worth. A few former residents with national fame grew up here. Included in this elite group are the television star Lisa Whelchel from the show *Facts of Life* and Lee McLaughlin, a stunt man and actor in Hollywood. Other members of the McLaughlin family still train horses in California as well as teach riding to actors, but their photographs are not included. Also of local fame is Mary Lou Reddick, for whom the library at Lake Worth is named. She worked tirelessly to start a library in Lake Worth.

There are many noteworthy places in Lake Worth, including outstanding parks such as the Rayle Park with its historical water tower and beautiful pond complete with a bridge built by a local resident known as "Frenchy." Other places of special interest include the Fort Worth Nature Preserve built on the shores of Lake Worth, the Shuman Boy Scout Camp, the Sokol Gymnasium, and National Hall, which for decades was known as the Bohemian Club.

At least two of the earliest rock houses in the area are included in this chapter because of outstanding features. The Whiting Castle still stands with its majestic edifice looking toward Lake Worth, as does the meandering road that winds around Lake Worth, where amazing sunrises and stunning sunsets may be seen reflecting on the historical water reservoir. Mosque Point and Inspiration Point continue to be favorite places to visit.

There are many other people, places, and things that have created Lake Worth's rich tapestry. It is regrettable that all cannot be shown, but it is suggested that readers visit the parks and the library and learn more about Lake Worth at the museum of the Lake Worth Area Historical Society, which is expected to be completed within the near future.

This photograph includes the Hodgkins family and part of the White and Low families. From left to right are (first row) Dudley Hodgkins Jr., Joe Earl Hodgkins, David Hodgkins, Sara Elizabeth Hodgkins (child), and Dale Hodgkins; (second row) Dorothy Hodgkins, Margaret Hodgkins, Lancing Hodgkins, Elsie Hodgkins, Vivian Hodgkins White, James Hodgkins holding infant James White, Sara Elizabeth Hodgkins holding infant Hugh Low, and Hallie Hodgkins; (third row) Howard Hodgkins, Tommy Low, Earl Hodgkins, Archie Hodgkins, Hubbert White, Everett Hodgkins, Harold Hodgkins, and Dudley Hodgkins Sr. Dudley Hodgkins Jr. wrote the history of Lake Worth long ago in a 29¢ booklet. The Fort Worth Public Library has what may be the only copy. (Courtesy Hodgkins and White families.)

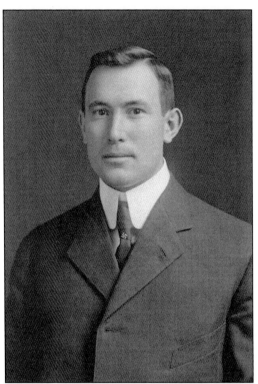

William Charbonneau, a founding father of Lake Worth, is shown here. He owned extensive land and generously gave or sold some of it to schools and churches, raised Perchoron horses, and served on the first school board. He also owned several hundred acres dating back to the mid- to late 1800s that the City of Fort Worth acquired as part of property needed to build the Lake Worth Reservoir. (Courtesy Ben Mauldin.)

J. R. Foster looks pleased as he sits on the sofa for this photograph taken in the mid-1940s with his family. From left to right are (seated) daughter Duena Myers; Foster's wife, Tessie Ella; Foster; and daughter Beverly Potishma; (standing) daughters Clara Woodall and Grace Johnson. (Courtesy David Woodall.)

Tessie Ella Foster looks lovely sitting on her decorative bench placed near her pretty rock house. One can imagine sitting here for a chat. Having a large family, she probably had no trouble finding someone to enjoy doing just that. Many of the older residents of Lake Worth tell of the beautiful landscape around this house. The bench fits in nicely. (Courtesy David Woodall.)

Amon G. Carter, a wealthy businessman from Fort Worth, purchased over 600 acres mostly in Lake Worth from George Reynolds, vast land holder and cattle baron, in 1923. On this heavily treed acreage, Carter built a ranch house called Shady Oaks where he entertained many famous people, including Pres. Franklin D. Roosevelt. (Courtesy John Degroat.)

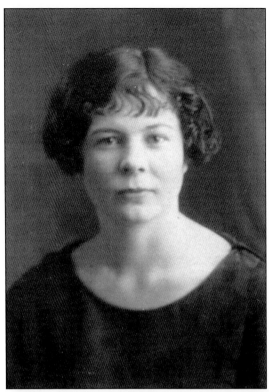

Octavia Newman, 22, was the first telephone operator in Lake Worth in 1928. She worked for T. P. Bearden's phone company and had known him from living in Baird, Texas. He owned many phone companies all over Texas and Oklahoma. (Courtesy Eddie McKay.)

This is a picture of Octavia Newman (right) when she was 89 years old and celebrating her birthday with daughter Eddie McKay. Newman moved away from Lake Worth for a while but came back and made her home here. She died at the age of 99 years and six months. (Courtesy Eddie McKay.)

Ford Maudlin (right) is shown here at Scout camp with his friend Buddy Wyman, who was the Scout leader of the troop in Lake Worth. Both men were heavily involved with the schools and encouraged the youth to be all they were capable of becoming. (Courtesy Myrt Fowlkes.)

This is a photograph of a Scout banquet with many in attendance. Unfortunately this picture only shows about half of those attending. The original small group of boys grew over the years, and within this book is a picture of the first group to receive the Eagle Award. (Courtesy Ben Mauldin.)

This well-liked man, R. E. Cooke, was known as "Cookie" and was a volunteer fireman for Lake Worth. His love for photographing just about anything earned him the title as the "unofficial photographer of Lake Worth." His camera seemed to always be where he was according to most of his friends. He captured many images of Fort Worth as well as Lake Worth. (Courtesy Lake Worth Library, Virginia Ross.)

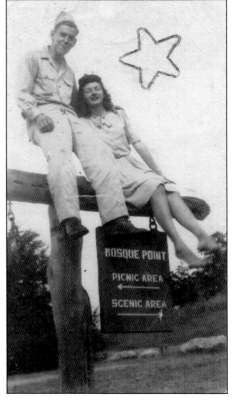

This unidentified military fellow looks like he is floating as the pretty unidentified young lady sits on the sign rail. The photograph is believed to have made in the mid-1940s. They must have felt like adding a little something to the photograph with the star on the right. (Courtesy Ben Mauldin.)

Lisa Whelchel, the beautiful young woman shown here, grew up in Lake Worth. As a teenager, she starred on the television show *Facts of Life* for many years and later married a minister. She currently is a Christian motivational speaker and has written a number of books. (Courtesy Matt Kroeker, Alliance Artists Agency.)

To Lawana & Ben
My Best friends
Lee McLaughlin

Lee McLaughlin, a loved and respected stunt man and actor, lit up a room when he entered. His talents allowed him to have a career he loved. Hollywood had a great former Lake Worth resident, and after his death, a host of friends and relatives greatly felt the loss. Shown here with McLaughlin is John Wayne. (Courtesy Ben Mauldin.)

Graduating from Lake Worth High School, Lee McLaughlin proudly walked beside his friend Johnny Mattox, who was also graduating. Even after Lee left Lake Worth for Hollywood, he came back often and always called or visited his friends. His humorous Christmas cards always brought a smile to his friends. (Courtesy Beth and Paul Harmon.)

Ben Mauldin received the Hodgkins Award from the Northwest Chamber of Commerce in January 2007. Mauldin was instrumental in getting a post office for Lake Worth as well as helping to implement a resurgence of the chamber of commerce in this area. He once owned a printing company in Lake Worth and currently owns commercial property there. (Author's collection.)

The Lions Club in Lake Worth, Texas, received recognition for having the most members at some point possibly in the 1950s. This occasion was cause for a celebration, which was held in the gymnasium of the old school on Telephone Road. Members are unidentified, as are visiting members from other clubs, some from nearby Azle, Texas. (Courtesy Harry Beason Jr.)

Bill Bezner was on the Lake Worth Independent School Board when the new high school opened in the early 1980s. He served on the Park and Recreation Board for the city during the 1970s and 1980s. In addition, he was commissioner of baseball and football for the Lake Worth Youth Association and served on the Zoning Board and Board of Adjustments. He also enjoyed hunting and fishing. (Courtesy Carla Bezner.)

Sam Petty was a man who enjoyed living in Lake Worth and serving the community just as his son-in-law, Bill Bezner, did. Petty ran for mayor in the early 1950s and was city inspector in the 1990s. He is shown here on his 79th birthday at a party given by his family at Vance Godbey's garden at their Boyd farm. (Courtesy Carla Bezner.)

The Bud Irby Senior Citizen Center was named after Irby for his dedicated years of serving as city secretary. In addition, Irby was manager of Casino Ballroom for 30 years. The building needs much repair, and the seniors no longer meet there. They temporarily meet in a nearby church and soon will enjoy a new building planned as part of a city complex. (Author's collection.)

Beth and Paul Harmon have contributed much time, talent, and money to the city of Lake Worth. Both were instrumental in the completion of Rayl Park. Paul Harmon served on the city council 12 years and the school board 8 years and also designed elements of various parks within the city. He and his wife received a certificate of appreciation from the city a few years ago. (Courtesy Harmon family.)

Camp Leroy Shuman is a leadership training facility for the Boy Scouts of America. Built in 1920, it is located in Fort Worth but is in an area near Lake Worth Reservoir. The camp may be used by both Scouts and Cub Scouts. Named after Leroy Shuman, who was in the first troop of Scouts and died shortly after graduating high school, the camp includes several buildings located on the property nestled among many trees. (Courtesy photographer Ken Brower.)

Henry Tschirhart, known as Frenchy, is standing on the bridge he built to cross over the pond in Lake Worth's Rayl Park. A man with a French accent and many talents, he is a skilled craftsman. Tschirhart enjoys raising vegetables and has several beautiful koi in his fish pond. (Courtesy Janice Tschirhart.)

Dub Ray and his wife, Kay, pose for a modern photograph. Ray's father, Roy Ray, owned Ray's Grocery in Lake Worth when Dub was a young man. Dub Ray still has a twinkle in his eye when he tells you he is 91 years old and has never lived more than 5 miles from where he was born except for when he was in the military service. (Author's collection.)

Sokol Gymnastics dates back to 1913 and is the oldest continuously operating Tarrant County gymnastics club. The owners strive to encourage all ages to participate in activities offered in their facility to help attain the maximum benefits of a healthy body. The club is located at 6500 Boat Club Road, on the edge of the city limits of Lake Worth. (Author's collection.)

National Hall was built in 1938 and is also on the edge of Lake Worth city limits. This is a Czechoslovakian organization that dates back to 1910 when a group met in the home of Frank Paprskar, where they conducted all business in the Czech language. For years, many referred to the facility as the Bohemian Club. The hall may be rented for special events. (Author's collection.)

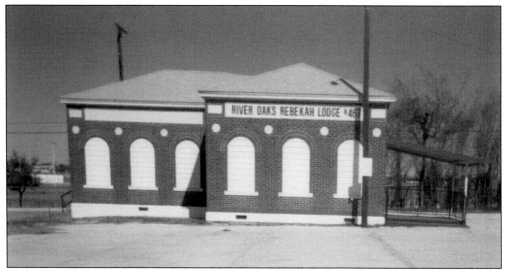

This structure once served as a transmitting station for WBAP, which started as a subsidiary of Carter Communications. Built in 1928 at 6020 Graham Street, on Amon G. Carter's Shady Oaks Ranch at one of the highest points, the station was moved to another location in 1929, but the building remains. A fraternal lodge meets here in the altered original building. (Author's collection.)

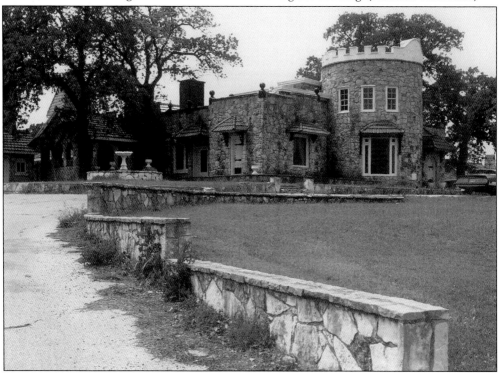

The Whiting Castle, an enchanting home designed mostly by Elizabeth Whiting in the late 1920s, took 19 years to complete. Legend has it that Samuel Whiting had won the site, which overlooks Lake Worth, in a poker game. Most would agree the couple used the property wisely. Several famous people have been guests in the castle, which has had several owners within the last four decades. (Courtesy John Degroat.)

"A floating night club" might describe the boat *Alvez*, which anchored in Lake Worth waters long ago. The steam-powered paddleboat blew up one night and sank to the bottom of Lake Worth after being open just a short while. Amazingly, the sunken vessel recently resurfaced when the water level was very low. Art Jones, newspaper owner, researched to confirm it was the *Alvez*. (Courtesy Earl Fowlkes.)

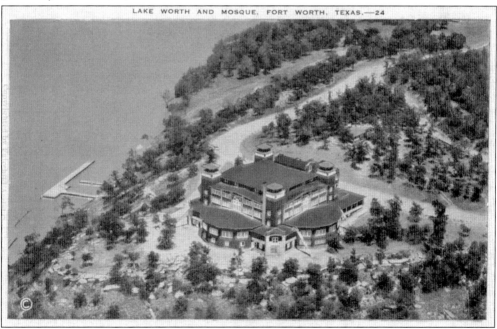

Situated on a hill above Lake Worth, this mosque was built of wood by the Masonic Lodge around the mid-1900s. Fancy dinners and other events were often held here. After just a few years, the magnificent building was destroyed by fire and not rebuilt in this location. (Courtesy John Degroat.)

Amon G. Carter had a hunting lodge on property that eventually had a finger of Lake Worth Reservoir running behind it. The property faces the road in front of it. The rock structure was built in 1904 and has had several additions. In 1928, the property was deeded to Mr. Palmer. It is owned by another family at this time. (Courtesy Geoffry and Theresa Oliver.)

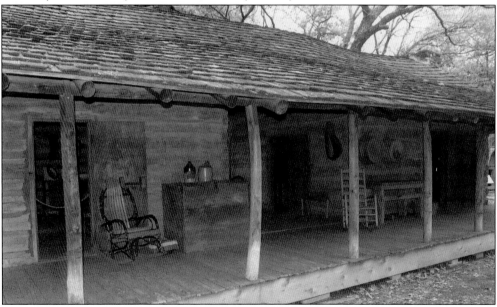

This log cabin belonged to Isaac Parker, uncle of Cynthia Parker, who was kidnapped by Comanche Indians. In 1920, Amon G. Carter bought the cabin and had it moved to his Shady Oaks Ranch for his Americana collection. After Carter's death, the cabin was donated to the Pioneer Heritage Foundation. It presently is located at the Log Cabin Village in Fort Worth. (Courtesy photographer Ken Brower and Log Cabin Village.)

Quentin McGown IV has this historic c. 1940 photograph of Inspiration Point. The site overlooks Lake Worth, in Marion Samson Park, and offers a panoramic view of the lake, dam, and fish hatchery. As part of a CCC project, a rock shelter house was built at the site, which at one time had a history of being the most used "spooning spot" in Tarrant County. (Courtesy Quentin McGown IV.)

William W. Merrett, a county commissioner but not the first mayor of Lake Worth as some believe, built this house in 1937. A street was named after him in this city. Like Lee Pope, Merrett achieved many accomplishments. Some believe he assisted A. W. Mills, the first mayor, in obtaining the installation of a water system for the Indian Oaks addition. (Courtesy photographer by Ken Brower.)

Lee Pope, deacon for Indian Oaks Baptist Church, president of the school board, mayor of the city, and judge for the Precinct Justice Court, moved to Lake Worth in 1932. Jack Shaddy, his fishing buddy, wrote, "We are not only fishers of men like Peter, James and John, but also fishermen of fish." Lee Pope must have agreed, for they made many fishing trips together. (Courtesy Jack Shaddy.)

This is a Rayl Park view from a different perspective than the earlier photograph. The bottom of the beautiful pond has a natural rock bed, and the rock on the side came from an excavation site for another park a few miles away in the Boat Club estate addition. Note the winding trails that meander throughout the park. (Author's collection.)

The Fort Worth Nature Center and Refuge, located on land surrounding one large portion of Lake Worth, was originally labeled state park No. 31 in the late 1930s and did not include as much area as it does now. The federal government once owned the land. Different stages of development are still occurring. Lookouts, wildlife, and trails are but a few of its amenities. (Courtesy Suzanne Tuttle, Fort Worth Nature Center.)

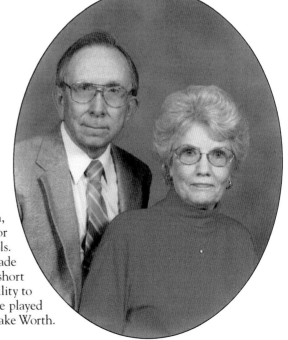

Jack Shady and his lovely wife, Velma, are shown here. Jack was the first editor for the newspaper in Lake Worth's schools. His witty comments and observations made him a favorite among his classmates. A short fellow, he stands at least 12 feet tall in ability to write about life. In spite of his height, he played basketball on the first basketball team at Lake Worth. (Courtesy Jack Shady.)

Myrtle Belle (Laverty) Fowlkes was the first police dispatcher for Lake Worth in 1952 after radios were issued to the police department and the fire department. Her duties at city hall were multi-dimensional in that she was the only worker in the office. In 1989, she served on the school board and on the city council for several terms. She is president of the local historical society. (Courtesy Myrt Fowlkes.)

Featured here is the Foster House awaiting a foundation, replacement of rock, and renovation. The house was recently purchased and moved from its former location to this site to become the future museum for the Lake Worth Area Historical Society. The history and beauty of the house make it an ideal choice for this endeavor. (Courtesy Jami Woodall, Economic Development Lake Worth.)

Walter Bowen, longtime council member, has been mayor of Lake Worth for 13 years. He was a volunteer fireman for Lake Worth and served 26 years as a referee for basketball. A man of great compassion who listens and responds to the community's needs, Mayor Bowen's love for America is often reflected in the wearing of his patriotic red, white, and blue shirt. (Courtesy Pat Bowen.)

Today's Lake Worth includes many churches, schools, shopping areas, doctor's offices, a post office, a city hall complex, a host of fine eating establishments, insurance offices, mortgage companies, and several banks just to name a few of the businesses incorporated into its profile. A shopping center is featured in this photograph. Many feel this community is a delightful place to call home and reflect on its rich past. (Author's collection.)

Discover Thousands of Local History Books
Featuring Millions of Vintage Images

Arcadia Publishing, the leading local history publisher in the United States, is committed to making history accessible and meaningful through publishing books that celebrate and preserve the heritage of America's people and places.

Find more books like this at
www.arcadiapublishing.com

Search for your hometown history, your old stomping grounds, and even your favorite sports team.

Consistent with our mission to preserve history on a local level, this book was printed in South Carolina on American-made paper and manufactured entirely in the United States. Products carrying the accredited Forest Stewardship Council (FSC) label are printed on 100 percent FSC-certified paper.

MADE IN THE USA